CARDIFF CHURCHES

THROUGH TIME

Jean Rose

Acknowledgements

Father Dean Atkins (St German & St Saviour, Roath); Geoff Atkins (Calvary Baptist); Pat Barry (St Peter's Roman Catholic); Pastor Desmond Cartwright RIP (Elim); Jeff Childs & members (Roath Local History Society); Alastair Clarke (Woodville Road Baptist); Father Harold Clarke (ex-Roath St Martin); Tricia Coulthard (Wales & the Marches Catholic History Society); Michael Cross & Leighton Hargest (Heath Evangelist); Barry Davies (St Denys); Revd Caroline Downs & Chris Berry (Parish of Cathays); Revds Marc & Alison Dummer (Canton Uniting & Parkminster); Revd Phil Dunning (Bethany Baptist); David Evans & Jenny Rote (Highfields); Father Graham Francis (St Mary's Butetown); Mary Gibbons, Stuart Bailey & Sheila Cannell (Conway Road); Jean Gough (St Anne's); Teifion Griffiths (St Margaret's); Richard Hall (St John the Baptist); Allen Hambly (Rumney Local History Society); Father Irving Hamer (Roath St Martin); Anne Herbert & Joel Sainsbury (City United Reform Church); Simon Hillard & Father Mark Preece (St John the Evangelist); Pamela Ivins (St Samson's); Revd Denzil John (Tabernacl); Pat Johnson & Father John Maguire (St Mary's Canton); Beryl M. Jones (Albany Baptist); Professor J. Gwynfor Jones & Bob Roberts (Eglwys y Crwys); Dr Michael L. N. Jones (Salem); Rhys Jones (Eglwys Dewi Sant); Glen Jordan (Butetown History & Arts Centre); Revd Keith Kimber (ex-St John the Baptist); Dr Nick Lambert (Birkbeck Coll); Hannah Lomas (Press Officer) & staff of James Howell (House of Fraser); Dr Alan Mayer (St Edward's, Roath); Brian Mayor (Ebenezer Grangetown); Saffron Herbert & Media Wales Ltd; Revd Peter Noble (Lightship); Mair Owen (Bethel Welsh Wesleyan Methodist); Sandra Palmer (Ely Meth); Sue Parsons & Father Martin Colton (St Catherine's); Angela Parry (St German's); John Rhys & Revd Peter Cruchley-Jones (Beulah); Teresa Robinson (St Thomas); Revd Mark Rowland (West Cardiff Methodist Circuit); Jenny Tarr (St Mark's); Eric Treharne (Llandaff Cath Archivist); Pastor Jeremy Tremeer & Ian Matthews (7th Day Adventist Church); Revd Alun Tudur (Ebenezer Welsh Independent); Stewart Williams (author of the *Cardiff Yesterday* series); Ann Wintle (St Fagan's); John Winton (Church Tourism Network Wales). Apologies for anyone omitted.

All the above helped with photographs, information or access, or all three, but special thanks must go to Nigel Spinks, fellow church enthusiast, for information and contacts; to Katrina Coopey (Cardiff Central Library Local Studies); Stephen Rowson's postcard collection, for numbers of old pictures; and above all to the indefatigable Bob Hyett, friend and choirmaster of St Margaret's, for taking almost all of the excellent present-day photographs.

While acknowledging the help of all these people, the responsibility for any errors within the book is entirely my own.

First published 2013

Amberley Publishing
The Hill, Stroud
Gloucestershire, GL5 4EP

www.amberley-books.com

Copyright © Jean Rose, 2013

The right of Jean Rose to be identified as the Author of this work has been asserted in accordance with the Copyrights, Designs and Patents Act 1988.

ISBN 978 1 4456 1092 4

British Library Cataloguing in Publication Data.
A catalogue record for this book is available from the British Library.

Typeset in 9.5pt on 12pt Celeste.
Typesetting by Amberley Publishing.
Printed in the UK.

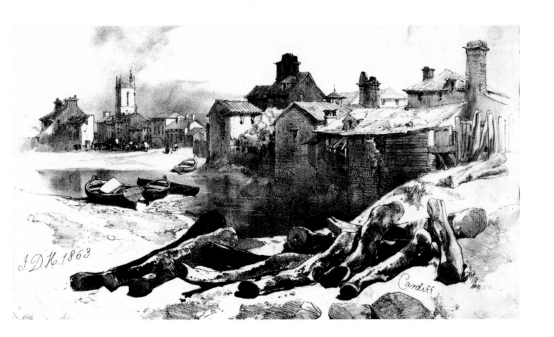

Contents

Introduction

In our twenty-first century, churches, for most people, mean weddings or funerals. Far fewer of us are regular attendees than we were a hundred or even fifty years ago. Townscapes have altered, with high-rise buildings, large shopping malls and multistorey car parks dwarfing the religious structures that once dominated the skyline. They have become strangely invisible. Yet these churches and chapels, the repositories of the collective memories of their communities, open our eyes to our hidden local history, and still provide places of sanctuary and support in stressful times. Smaller congregations find it challenging to maintain and preserve this historic fabric. The great cathedrals flourish, but the rest of our religious heritage is in danger of being forgotten. Yet these buildings can tell us who we were and point to what we might become.

Cardiff prides itself on being a modern city and one of Europe's youngest capitals, drawing visitors from all over the world. As well as shopping in the gleaming St David's Two, everyone visits Cardiff Castle and the fine Civic Centre, and some discover the commercial legacy of Butetown. Fewer are aware of the rich variety of churches to be found in the city, most of them from that period of phenomenal growth in the nineteenth century when the little town grew to become the world's largest coal port, the 'Chicago of Wales'.

From Norman times, just two churches served the town until the late seventeenth century when the first Nonconformist chapel was built in Womanby Street. One hundred and fifty years later, following the opening of the Glamorgan Canal, the first Bute dock and the Taff Vale railway, the population had increased exponentially. The crowded streets and courts of the town centre and Butetown spawned churches and chapels on almost every corner. Today, after population shift and drift, urban redevelopment, wartime bombing, and religious climate change, many of these have relocated or simply disappeared. The survivors have adapted to the modern world but still proclaim their message and work hard for the good of their communities. They welcome residents and visitors alike and are sites of pilgrimage and historic places to explore and enjoy, a consistent thread in the tapestry of Cardiff's heritage. This book is hopefully a helpful attempt to make them more visible.

Jean Rose

Sources

The following books or articles have been consulted: Brown, R. L., *Irish Scorn, English Pride and the Welsh Tongue* (1987), *Ashton's Little Game* (www.capeli.org.uk); Fielder, G., *Grace, Grit and Gumption* (2000); Hilling, J., *Cardiff and the Valleys* (1973), *Cardiff's Temples of Faith* (2000), *History of St Peter's Parish Roath* (2001); Hargest, L., *Holding Forth the Word of Life: History of Heath Evangelist Church* (2000); Jenkins & James: *History of Nonconformity in Cardiff* (1901); Jones, B., *Images of Wales: Canton* (1995); Jones, J. G., *Cofio yn Gobeitho* (1984); Lloyd, A., *History of Methodism in Cardiff Docks* (1991); Newman, J., *Buildings of Wales: Glamorgan* (1995); New Trinity, *History of Cardiff's Oldest Nonconformist Church* (1987); Read, J., *The Church in our City* (1954), *History of St John's Parish* (1995); Williamson, J., *History of Congregationalism in Cardiff and District* (1920); Winks, W. E., *History of Bethany Baptist Church Cardiff* (1906); Williams, R. H., *Hanes Salem Canton 1856–2000* (2006).

CHAPTER 1

Llandaff Cathedral

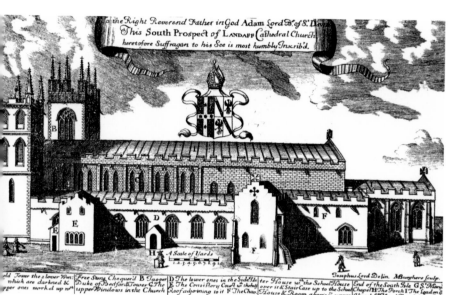

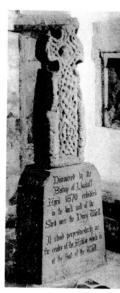

The Cathedral of Llandaff – Anglican since the Reformation – is the mother church of a diocese covering almost the whole of Glamorgan. The village of Llandaff, 2½ miles from the city centre, became part of Cardiff as late as 1922. The cathedral's foundation is ancient, lost in the mists of time. St Teilo may have come here about 560 CE and founded his 'little minster' in a secluded hollow beside the River Taff – hence 'Llandaff' – but Saints Dyfrig and Euddogwy are also cited as founders; it was all so long ago. Teilo was the name revered here until the Reformation, when pilgrims flocked to his silver gilt shrine. On the right is a Celtic cross in the present south aisle. It is the only remaining relic of the 'Age of Saints'.

Lavishly carved doorways and chancel arch date from the time of the first Norman bishop, Urban, while nave, west front and choir are in a serene Early Gothic style. Llandaff was never a rich diocese, and a combination of poverty, neglect and absentee bishops would imperil its future. The lithograph above shows it in 1717, before the collapse of the south-west tower.

After the Civil War, when Cromwell's troops used the nave as a beerhouse and the font as a pig trough, storms in the early 1700s severely damaged both west towers. The nave roof fell in and the church became an ivy-covered wreck – 'the poor desolate church of Llandaff'. In 1734, a partial restoration by John Wood of Bath resulted in a classical 'temple' being built within the ruins. Two classical urns from that time now stand outside the Prebendal House. In the 1840s came industrial prosperity, and Llandaff again got a Dean and resident Bishop. Local architect John Prichard was charged with a complete restoration, to which he added the glorious south-west tower and spire, considered controversial and continental at the time. His partner, J. P. Seddon, brought in glass, carvings and paintings by members of the pre-Raphaelite school, some of which survived the next trauma, a landmine of 1941, which again wrecked the building. A final restoration in the 1950s by George Pace added a Welch Regiment chapel and the striking *Majestas*.

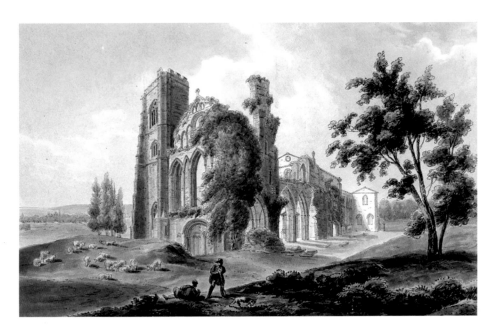

Ruin & Restoration

This eighteenth-century watercolour of the ivy-clad ruin – such as were prized by the Romantics – shows the sorry state of this still functioning cathedral. John Wood's 'Italian Temple' is just visible above the arches. Prichard's restoration of the 1850s was a triumph of Victorian vision and energy, shown below in the view from the west front and the elaborate neo-Gothic interior looking towards the chancel and sanctuary.

Looking eastwards from the west end of the nave, we see Prichard's recreation of the stately Early English style nave arcades, the Victorian pulpit and organ (with trumpets!), and the Rossetti triptych in its intended place as a reredos behind the high altar. The view today, at floor level, is much more open with a vista through to the Lady Chapel. The fine Rossetti piece, beautifully restored in recent years, now stands behind the altar in the St Illtyd's chapel in the north-west corner of the cathedral.

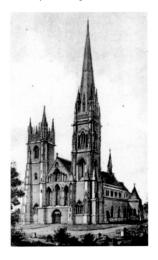

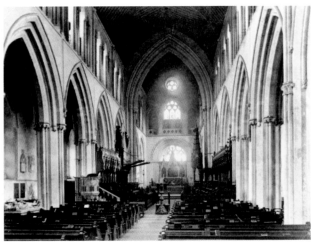

War Damage & Renaissance

The landmine of 1941 fell just where the photographer stood to take this shot. The devastation of the roof, windows and chapter house with its conical top is all too evident to any onlookers, no doubt bewailing the wreck of their beautiful cathedral. It would be almost twenty years before the second restoration was fully complete.

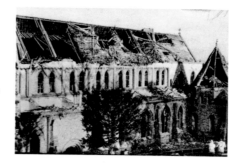

The nave today, looking eastwards, is dominated by the dramatic concrete arch carrying the organ case and the striking (and, to some, controversial) figure of the risen Christ – his hands open towards all who enter. The statue, by Jacob Epstein, was made in Lambeth and is of unpolished aluminium. Around the organ case are sixty-four gilded figures that decorated the canopies of the pre-war choir stalls. In 2010, the cathedral organ underwent major restoration, and now all is pristine again. Llandaff truly is a cathedral that has risen several times, like a phoenix from the ashes.

(*Inset below*) Prichard's glorious addition to the west front was this 195-foot spire, made unsafe by the bomb but restored to its full French-Gothic perfection.

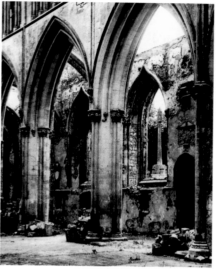

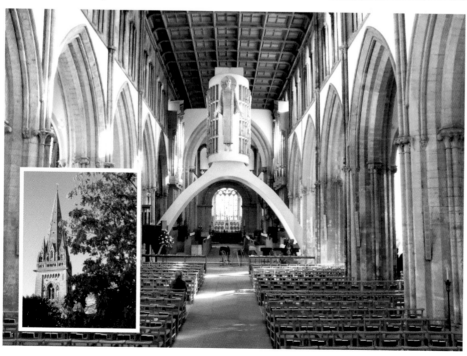

The Church in Wales (Anglican)

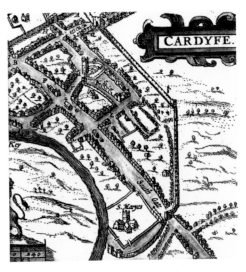

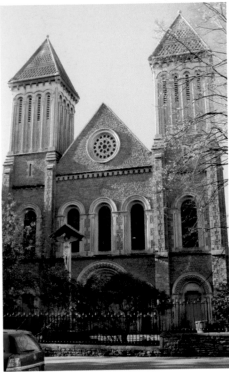

The old Celtic Church set up its altars in remote places – secluded valleys, hilltops and even tiny islands – believing that there one was closer to God. Cardiff had, as far as we know, no church until the Normans came in the 1080s. A warrior, yet a devout Catholic, the first Norman Lord of Glamorgan, Fitzhamon, built the priory church of St Mary near the town's south gate. John Speed's map of 1610, left, is its only visual record. A cruciform structure, it was staffed by the monks of Tewkesbury Abbey, Fitzhamon's major foundation, until the Reformation. It was, however, built very close to the River Taff, which gradually undermined its foundations. Eventually, after the tsunami-style storm of 1606 and the damage inflicted in the Civil War, the church was totally ruinous, and the people of Cardiff had to worship in the chapel of St John, seen near the top of the map. St Mary Street is still a main shopping street, but the St Mary's it led to is no more.

All these churches were of course originally Catholic, until the Reformation when the Welsh churches became part of Henry VIII's Church of England in the Province of Canterbury. In 1920 the Welsh Church was disestablished and separated from the Church of England, with its own Archbishop, and is still part of the Anglican Communion.

In 1839, the 2nd Marquess of Bute opened Cardiff's first dock, which, with the railway and canal, propelled the town into its period of phenomenal growth. Around his dock he planned a new town with elegant squares and grand buildings. St Mary's parish had never been dissolved, so he bought the living and gave the land, and by 1843 enough money was raised to build the new St Mary's to grace the approach to his 'Butetown'. Architect Thomas Foster of Bristol built in Anglo-Norman style, with pyramidal towers atop a dramatic east façade. This was in fact a sham, with fake windows and doorways. The present-day photograph shows an exterior virtually unchanged since the day it was built.

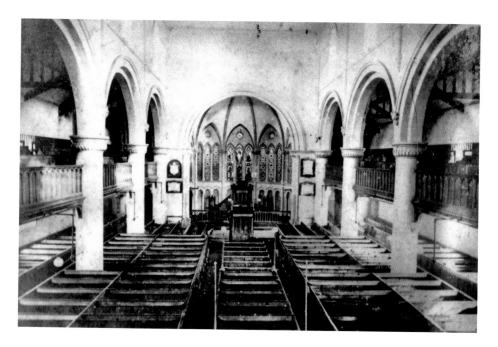

St Mary the Virgin, Butetown

St Mary's original interior could be likened to a chapel – a vast preaching house seating 1,800, with a central pulpit, three galleries, and an emphasis on 'the Word'. In the 1880s all that changed – under protest! – and the liturgy and fittings were Catholicised. It featured in the film *Tiger Bay*, and the most famous name in the baptismal register is that of Shirley Bassey. Below, a glorious view of the recreated 'Catholic' interior, seen through the Spanish-style screen from the demolished St Dyfrig's church in Wood Street.

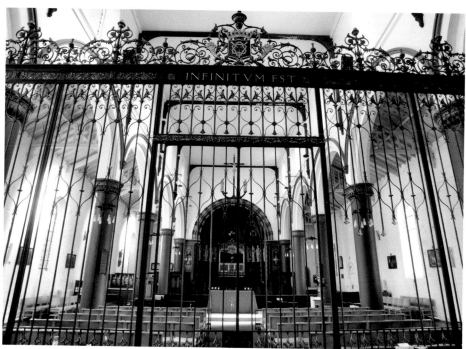

St John the Baptist Cardiff

St John's is the only medieval church in the city centre. A chapel of ease from 1180, it gradually took the place of St Mary's, becoming a parish church in the early seventeenth-century when the old church became completely ruinous. Much of the church had to be rebuilt after being sacked by Owain Glyndwr in 1404. Considering the damage he did, it is ironic that the pub opposite is named after him! In 1812, a new gallery was installed to accommodate former worshippers from St Mary's. Some seats were free but many are rented.

With population growth, a major expansion and restoration took place, 1886–89, under architect John Prichard, restorer of Llandaff Cathedral. The chancel was made higher and longer, the tower restored and north and south aisles added, replacing earlier galleries. The organ was moved into the former 'Aldermen's Aisle' where, from 1835, the Bute family would have sat. The 'Lord Mayor's Pew' still has the mace holders for the official civic services, and Council seats have the town arms on their ends. Leading artists of the day added beautiful fittings and stained glass. Unusually, a baptismal pool was set into the floor at the west end – a response perhaps to the popularity of the two Baptist chapels, a stone's throw from St John's? It hasn't been used for over 100 years. The most significant modern improvement is the two-storey vestry at the south-west corner, used for the choir, Sunday school and a tea room.

Victorian vicar Charles James Thompson (1875–1901) was a man of dynamic energy and vision who, while the church was being restored, held evening services in the Park Hall. Two thousand people were regularly spellbound by his sermons, which he gave entirely without notes. He helped raise £15,000 to restore St John's, and opened two new churches and several schools, while gaining an Oxford DD degree and climbing the Matterhorn! The chancel screen of 1911 is his memorial.

Today St John's is at the heart of the city and at the centre of civic life, but is also a quiet medieval haven in the midst of all the bustle. A weekday volunteer-run tea room is popular with both workers and shoppers. Its treasures are many, including heraldic glass, a seventeenth-century Herbert monument, a fine Renaissance screen, a Prichard Gothic reredos with statuary by Goscombe John, and a chapel of the Order of St John of Jerusalem, with gilded reredos by Ninian Comper. High in the tower hangs a peal of ten bells and, until 1914, the 'cruffin' (curfew) bell was rung at 8 p.m. each day. The tower, erected in 1473 and 'a fair steeple of grey ashlar', Somerset-style, is adorned by a forest of pinnacles and a lace-like parapet – it must be the most beautiful structure in the city. Occasionally open to the public, the fine views from the top make the steep climb worthwhile.

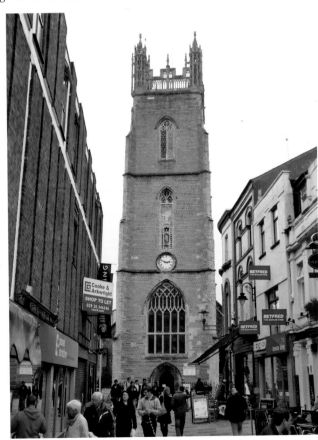

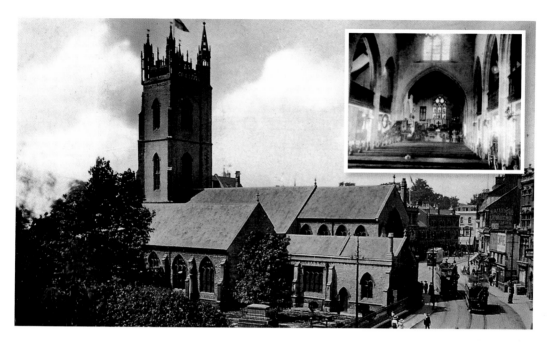

Outside St John's

These fine old postcards show the elegant proportions of St John's in the early 1900s and a pre-1889 interior. Trams run by the east end and a handful of people stroll past. A similar view today is very different: St John's Street is now pedestrianised and, at the weekend, thronged with shoppers.

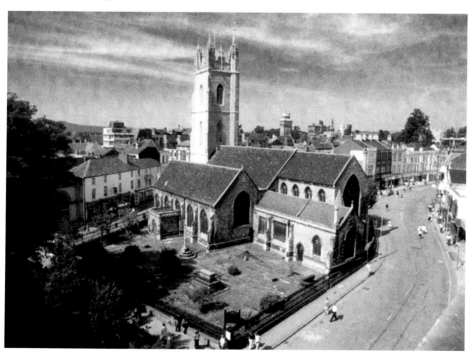

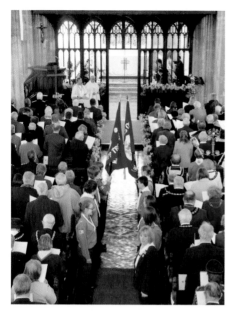

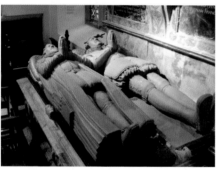

Inside St John's

One of the many civic services held in St John's. This one shows a recent St David's Day service, with clergy of all denominations, civic dignitaries and local people celebrating the Welsh national day in a church nearly overflowing. Also pictured left is the fine Herbert tomb (seventeenth-century). It is unusual that two brothers – one with a somewhat better reputation than the other! – lie together in monumental splendour.

The beautiful reredos, or altar piece, showing scenes from the life of Jesus with Saints George & Michael, is by Sir Ninian Comper and is a memorial to Lord Kitchener. It stands behind the altar of the Guild chapel of the Order of St John of Jerusalem, recreated in the nineteenth century and given a royal charter in 1888. The original Knights of St John, or Knights Hospitaller, were founded in the eleventh century to care for pilgrims to the Holy Land, and the modern order created the St John's Ambulance Brigade, still doing vital first aid work and training to this day.

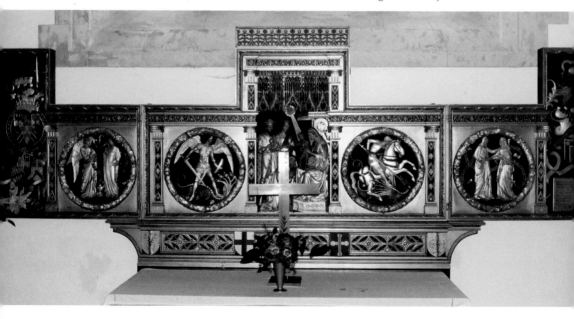

St Dyfrig & St Samson, Grangetown

St Dyfrig's, close to the Taff, was 'one of the most beautiful churches in the town'. Built in Arts & Crafts style by John Dando Sedding, the memorial stone was blessed by Charles Smythies, Bishop of Zanzibar and former vicar of Roath, in 1888. The church was on the edge of 'Temperance Town', a grid of small streets built for working men and their families from the 1860s, soon to become overcrowded and run down. The houses were demolished in 1938 and the bus station opened on the site in 1954. The church was isolated and vulnerable, and was finally demolished in 1969. Some of its treasures survive, however. The Spanish-style chancel screen went to St Mary's, Bute Street, but, perhaps best of all, the stunning reredos (*right*) now stands behind the altar of St Samson's, Grangetown. Made by artist Henry Wilson, it depicts the Adoration of the Magi, with St Dyfrig's first vicar, Hector Coe, as the model for the bearded king. St Samson's, a small mission church in the back streets of upper Grangetown, offered colourful sensory worship to drab lives when it opened in 1922 in Pentre Gardens. Never completed, the plain little church still flourishes and is enhanced by treasures from the demolished St Dyfrig's.

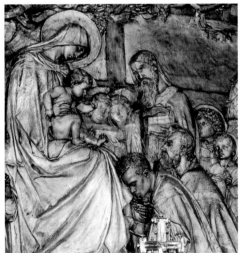

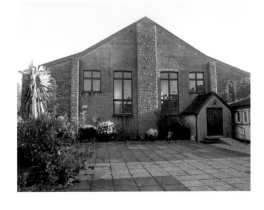

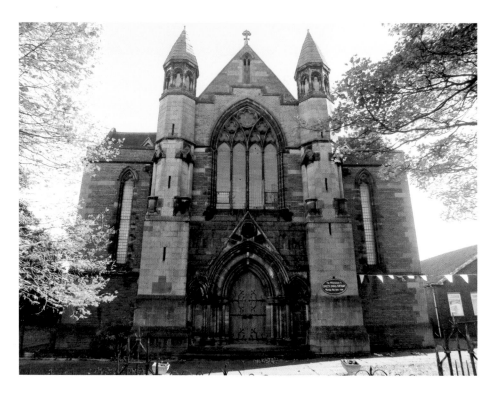

St Paul & St Barnabas, Grangetown

An impressive church of 1891 in Paget Street, St Paul's in Grangetown was designed by architects Seddon & Carter and funded by Lord Windsor. It has strong vertical lines, slender interior columns and a fine east window of 1920 by Burlison & Grylls. Now in need of repair, the church's future is uncertain.

As a daughter church of St Paul's, seating just 200, St Barnabas opened in Avoca Place in Saltmead in 1897. Another backstreet Anglo-Catholic mission, it offered fine ceremonial in the plainest of buildings. It was joined to St Samson's (*see page 13*) at the 1920 disestablishment. It closed in the 1960s and the site is now occupied by flats.

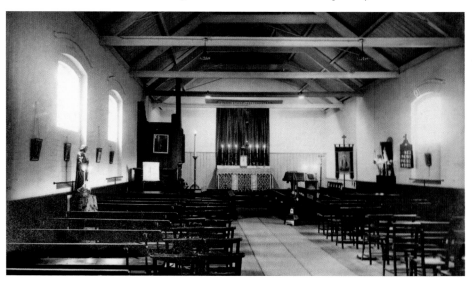

St John the Evangelist, Canton

The hamlet of Canton was part of Llandaff parish, but by the 1850s Bishop Ollivant felt it needed a church of its own. By 1900, it would be the largest parish in Wales. The church of St John the Evangelist, originally known as Christ Church, became the second place of worship in Canton. From 1855, it was built in stages by architects Prichard & Seddon, with the fine broach spire completed in 1871. A parish church by 1863, its first rector was Revd Vincent Saulez, of French Huguenot stock. He founded St Paul's church in Grangetown (*see page 14*) and St Catherine's (*page 17*), and made great efforts towards decent housing for the Irish that were moved out of the notorious slum courts of the town. Ethel and Daisy Streets were named for his daughters. Daisy founded the St Vincent's Mission, the forerunner of St Luke's church, in Victoria Park, built by architect George Halliday in 1910. St John's, on its grassy island site in a quiet corner of Canton, is perhaps the most impressive of Prichard's Cardiff churches.

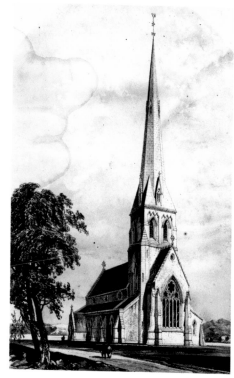

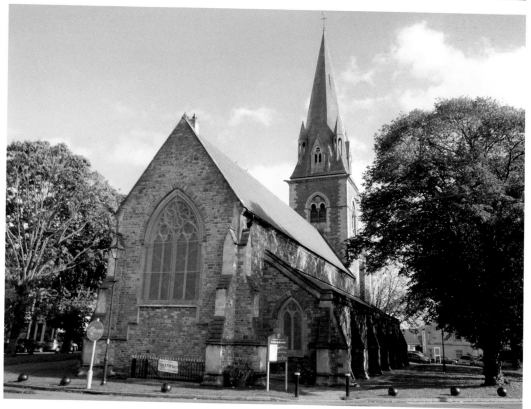

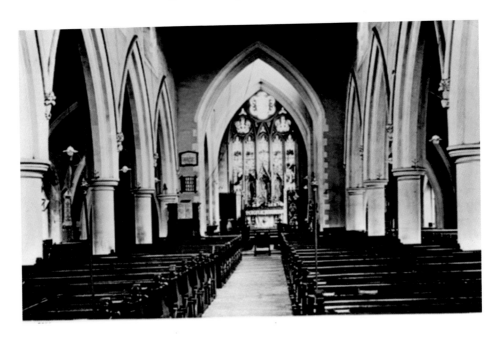

Inside St John's

Above, St John's handsome Victorian interior, with arcaded nave flanked by low aisles, and, to the east, a dramatic Ascension window. Its fine three-manual organ is a First World War memorial. In 1981 came brilliantly coloured abstract glass by Geoffrey Robinson, seen below. St John's underwent major refurbishment in 2009, also below, which brought in new seating, a nave altar on a platform and modernised facilities. Offering 'quality music at an affordable price', St John's is known for the high standard of its many recitals and concerts.

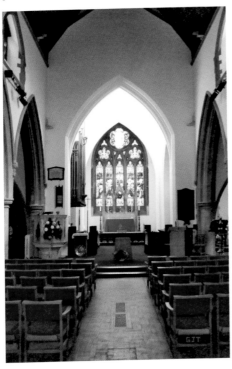

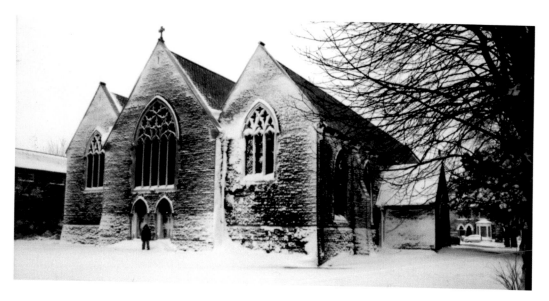

St Catherine's, Canton

St Catherine's in Kings Road opened in 1885, its dedication possibly influenced by the name of Catherine Vaughan, wife of the Dean of Llandaff. She laid the foundation stone and he donated £1,000 to the building fund. Later extended, in 1894 it became a separate parish under Revd Joseph Baker, who was vicar for thirty years. The photograph of the 1905 church cricket team (*below*) shows him seated centre, very much a gentleman of his time, with hat, gloves and fine moustache. The church has a handsome interior, with marble reredos and good stained glass, including some by Sir Ninian Comper. Woodwork is all in teak or mahogany, with 'no "Church Furnishers" stuff', said Vicar Baker. Today the church is part of the Rectorial Benefice of Canton.

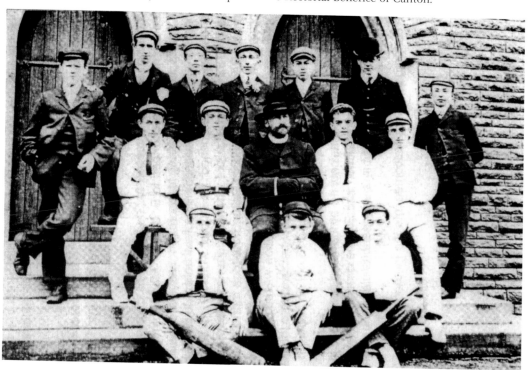

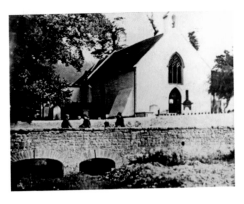
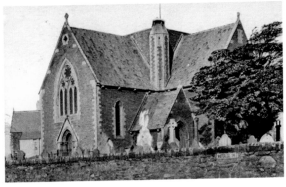

St Margaret of Antioch, Roath

The old, whitewashed church of St Margaret's in Roath dates from Norman times as a chapel of ease of St Mary's priory in Cardiff. A simple rectangular building with porch and western bell cote, the windows were enlarged over the years. The old Bute mausoleum added in 1800 is just visible behind the tree in the above picture. The church became rundown and too small for the fast-expanding suburb of Roath, and was demolished in 1867–68. It was rebuilt in 1870, at the expense of the 3rd Marquess of Bute, by architect John Prichard, who planned 'a tower and spire of outstandingly original design'. Sadly, the church had no tower at all for the next fifty-six years!

The tower was added by the parish in 1926 as a First World War memorial, and the churchyard, full to the brim with graves, was 'tidied' by the council in 1969. Most of the headstones were reduced to rubble, but the church does keep a record of them all. Each September the church opens on one of the European Heritage Open Doors Weekends, when visitors can enjoy guided tours and, weather permitting, climb the tower for panoramic views of the city and beyond.

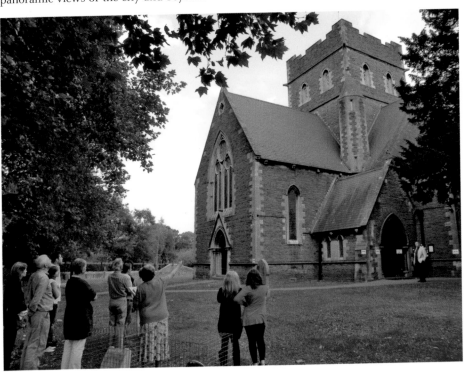

Inside St Margaret's

For years, St Margaret's shared a vicar with St Mary's (or other churches), but in 1872, because of the increase in the size of the parish, the church got its own vicar, Revd F. W. Puller from Oxford, with his High Church ideals. He and his curates, all single men and several with private means, worked tirelessly to bring Word and Sacrament to the people of this swelling suburb, who were largely unchurched. Before the arrival of Puller and his team, the vicar had been an Evangelical, W. Leigh Morgan, but the 'new' church interior shows the changes in the 3rd Marquess' building. No three-decker pulpit or galleries here, but a raised, unenclosed altar with reredos of the *Agnus Dei* and other Catholic symbols. Canon Morgan must have shuddered. The old photograph dates from before 1881, and shows the church decorated for Easter. The new St Margaret's would, in those last years of the century, become a flagship parish of the Anglican Communion.

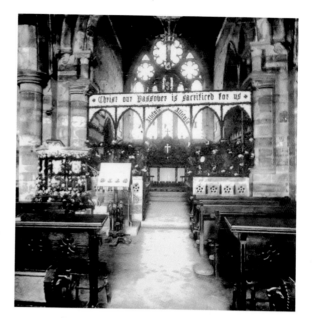

The interior today shows many of Prichard's fine fittings, but the choir stalls are modern, and the present reredos was installed in 1925 as a memorial to the first three vicars, Puller and his successors, one of whom, Charles A. Smythies, became Bishop of Zanzibar. Designed by Ninian Comper, it has fine gilded statuary of the Risen Christ and his twelve apostles. The glass of the huge east window was replaced in 1952 following a bomb blast, and shows the Ascension flanked by the patron saints of the daughter churches.

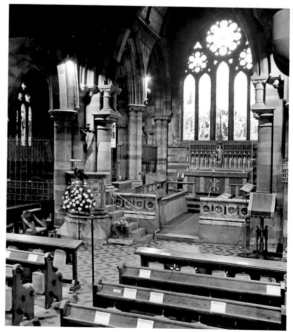

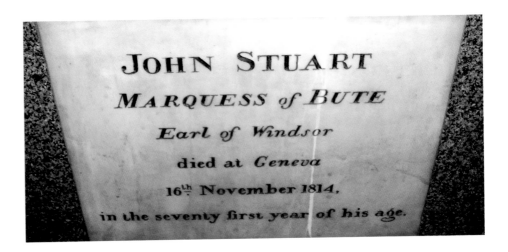

JOHN STUART
MARQUESS of BUTE
Earl of Windsor
died at Geneva
16th November 1814,
in the seventy first year of his age.

The Bute Mausoleum

The 1st Marquess of Bute married Charlotte Jane Windsor, the heiress to the Welsh estates of the Herbert family, in 1766. He thus became Baron Cardiff, with Cardiff Castle and huge swathes of land throughout Glamorgan. Later, at auction, he bought the Friars Estate, adjacent to the castle, and the livings of local churches, one of which was St Margaret's. When Charlotte died in 1800, he decided to build a family burial chapel, or mausoleum, attached to the little old church in Roath. Built as an extension, in the 1880s it was incorporated again by Prichard into the north-east corner of the new church; the sealing slabs from the original burials were retained in the later granite tombs. Above is the inscription to the Marquess himself, John Stuart, who died in Geneva in 1814.

 The Bute Mausoleum in St Margaret's is one of the finest examples of Victorian funerary architecture in Britain. The chapel is in an elaborate Gothic style, a deluxe version of the rest of the church, but the massive Peterhead granite tombs are starkly plain, perhaps modelled on those of the Tsars in St Petersburg. Only nine people were buried here between 1800 and 1832, as the 2nd Marquess lies with his first wife in Cambridgeshire and his son converted to Roman Catholicism after his twenty-first birthday. The Bute family has remained Catholic to this day.

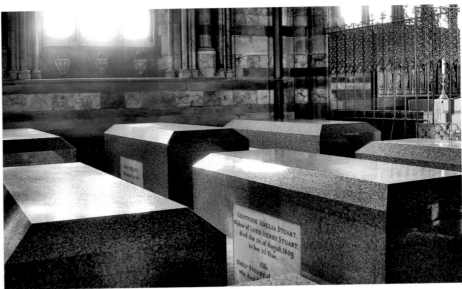

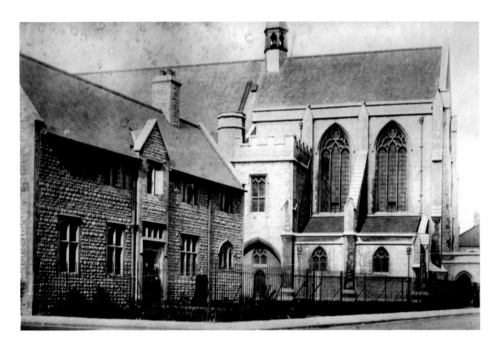

St German of Auxerre, Roath

St German's was the first daughter church of St Margaret's, founded by Father Puller who was anxious for church and school provision for his growing parish. He commissioned architect G. F. Bodley to build Metal Street National (church) Schools in 1874, acquired an iron building for the mission church, and, in 1884, brought back Bodley to build what would be called 'the finest Victorian church in Wales'. The picture shows the church with its striking flying buttresses – the only ones in Cardiff – and beside it, the clergy house – Bodley again, of 1894. It appears to be recently built – no trees in the garden – and the figure in the doorway is probably the first vicar, the long-serving and much loved Father R. J. Ives.

A similar view today, but the church is now obscured by a large tree and Metal Street has the inevitable cars and road signs. The clergy house is in need of some refurbishment and at the time of writing the future of the building that once housed a vicar and up to four curates is uncertain.

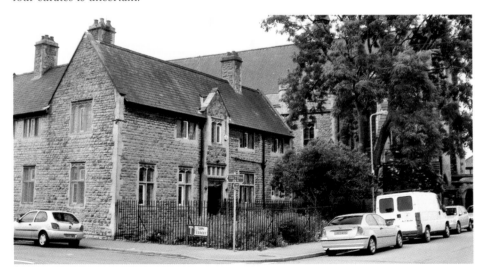

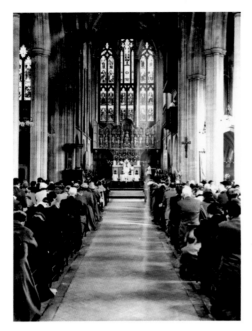
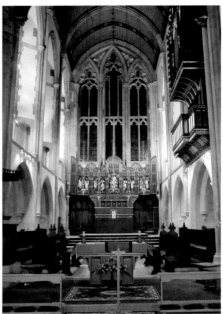

Inside St German's

The grand church of St German opened in Adamsdown in 1884, at the height of the Anglo-Catholic revival. 'A greyhound church, tall and lithe', it is spacious with cathedral-like proportions. The picture shows a high mass, with priest and servers in the sanctuary, and a full congregation, probably from a high water mark of churchgoing after the Second World War. The chancel photograph shows the spectacular Bodley organ case, the Decorated window tracery and the painted and gilded reredos, a memorial to old Father Ives. Today, with Reserved Sacrament, lights and bells, statues and Stations, St German's is still a bastion of Anglo-Catholicism in Cardiff. In the picture below, hundreds packed the church for a special farewell service to the retiring vicar, Father Roy Doxsey, in June 2011. Not in shot, his two Jack Russell dogs were present at this and every mass.

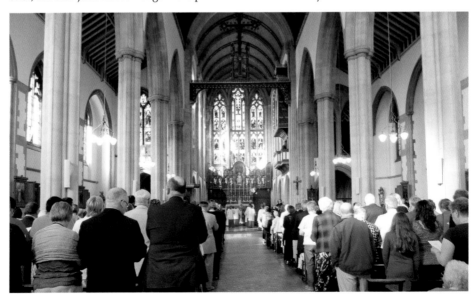

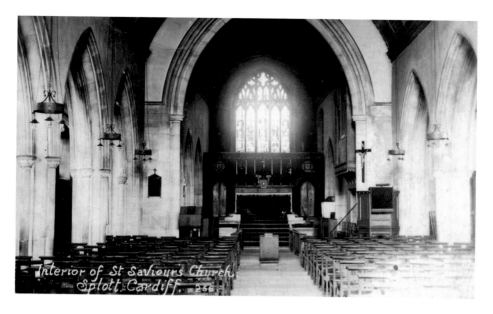

Interior of St Saviours Church, Splott, Cardiff. 256.

St Saviour's, Splott

Another Bodley church, St Saviour's, was built in 1888 in Splott Road, as a daughter to St German's, though unable to compete with it in grandeur. It was modelled on the church of St Mary, Tenby, but without tower or spire. A spreading church, the nave and chancel are flanked by aisles and side chapels, and enhanced by Stations of the Cross in aluminium by Frank Roper (1963) and a strikingly coloured modern reredos by local artist Tony Goble.

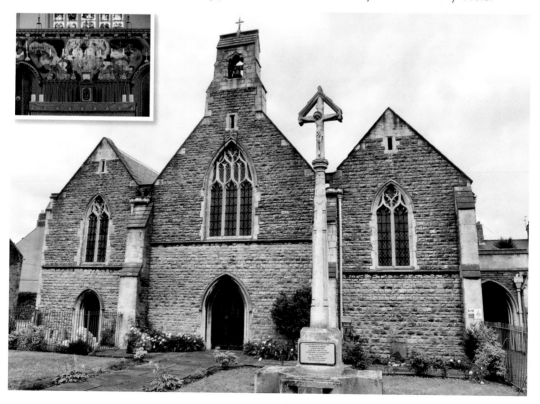

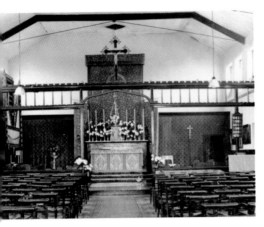
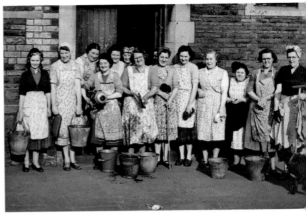

St Francis & St Agnes

Two of the many late Victorian backstreet mission churches. The first is St Francis, built in 1894 in Singleton Road, Splott, to serve those in the iron, steel and copper works on the East Moors. These cleaning ladies pose happily outside in a post-Second World War picture. The church closed in 1969, when much of lower Splott had been demolished and its people moved to outlying estates. The second is St Agnes, which opened in 1886 in the part of Roath south of Broadway. It was a drab little building on the outside, but a high church paradise within – 'the smoke (incense) so thick you could barely see!' Joined to St German, the church finally closed in 1966. A block of flats (and a chapel in St German's) keeps the name alive today.

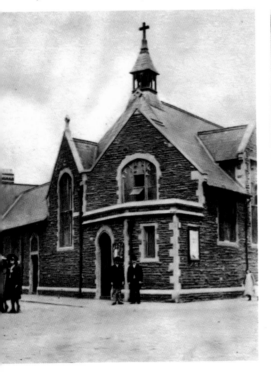
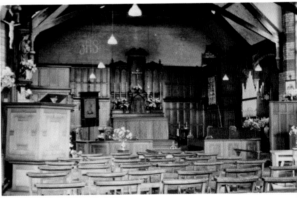

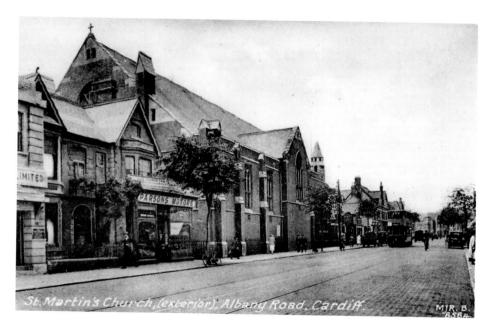

St Martin of Tours, Roath

St Martin's in Albany Road is in a sturdy red brick, built 1901 by F. R. Kempson, the diocesan architect, again to serve a growing district. In a late Gothic style, with raised altar, magnificent reredos and side chapels, the Lady Chapel was later decorated by a Belgian refugee of the First World War, in gratitude for the kindness of the parishioners. The lavish interior and roof were destroyed by an incendiary bomb in February 1941; only the Calvary, font and choir vestry survived. Services were held there and in neighbouring St Cyprian's until the church was fully restored in 1955. Albany Road was relatively quiet in this early twentieth-century postcard. There are few pedestrians and little traffic, including a fine double-decker tram – quite different from a similar view today.

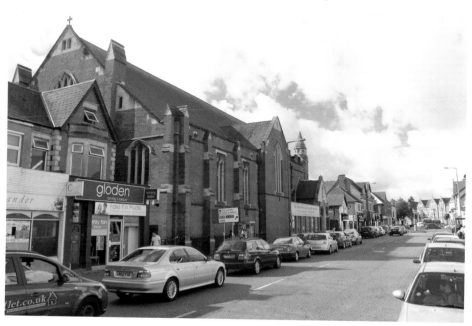

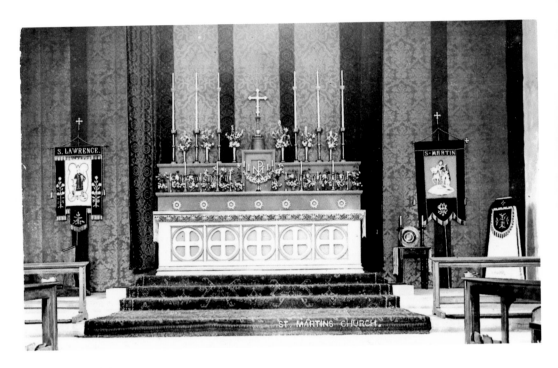

Inside St Martin's

This photograph from 1912 shows the high, unenclosed altar of St Martin's, bedecked with candles, flowers, lettering and Christian symbols. It is flanked by banners of the patron Martin, dividing his cloak for a beggar, and St Lawrence, patron of the poor, whose guild met in the church and to whom a Mission in nearby Adamsdown was dedicated. After the destruction of the Second World War, the interior of the church was redesigned in a lighter, simpler style. Chancel and altar were lowered and heavy tracery and glass replaced by clear lancet windows. Later, Frank Roper artwork was introduced and in 2011 a new cloister on the road side of the church was blessed by Archbishop Barry Morgan. Below, the 'new look' St Martin's, decked out for Easter.

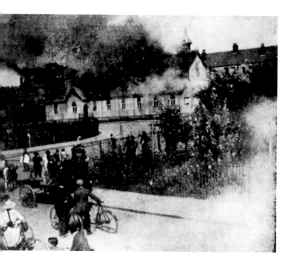
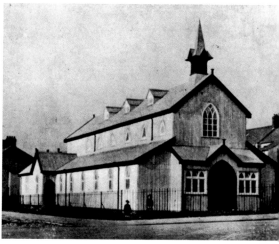

St Edward the Confessor, Roath

St Edward's in Blenheim Road was built as an iron church in 1915, but burnt down just four years later, probably due to an electrical fault. With the First World War recently ending, Roath parish decided to rebuild the church as a war memorial to the fallen. Built in brick with sandstone dressings by architects Willmott & Smith, only the chancel was completed, presumably for lack of funds, and a temporary nave added, again in galvanised iron. The pulpit, installed in 1953, came from All Souls' chapel (Missions to Seamen) in Cardiff docks (*see page 39*) and was given by the family of Revd Ken Martin, who was for many years the church's assistant priest. By 1968, the iron nave was in poor repair, and a permanent shorter one was built by the original architects. In 1992 a schoolroom, with vestibule and toilet, was added at the west end. Always a musical church, St Edward's has its own resident orchestra, with a piano school mid-week and an October music festival.

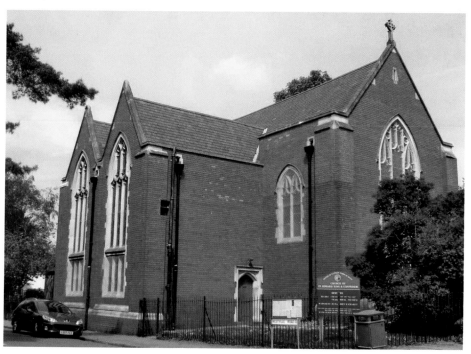

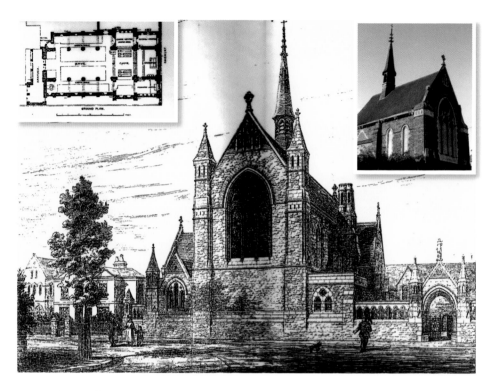

St Anne's, Roath

St Anne's in Plasnewydd was built on Mackintosh land, and succeeded St Clement's, a school chapel of 1875, another foundation by Father Puller of Roath. Architect Joseph A. Reeve's design (*above*) was shown at the Royal Academy Exhibition of 1887, but it was a triumph of ambition over finance and only the chancel and flèche (spire) were built in 1887, with the present plainer and lower nave added in 1893. The elaborate gates and transepts were never realised, though the blocked transept arches still remain. Never a rich church, the choir photograph from 1929, when youngsters had far fewer distractions, shows a fine complement of servers and choristers. The inset shows an impressive chancel even today.

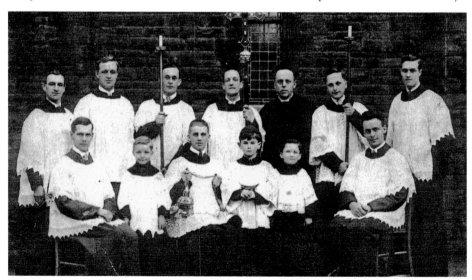

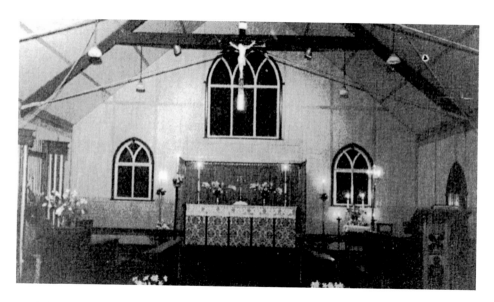

St Philip's, Tremorfa

This grainy old photograph shows the inside of St Philip's church, an iron building erected in 1937 to serve the new council estate to the east of Cardiff named Tremorfa, the 'town on the marsh'. This building, superseding a hall of 1930, had formerly been the Roman Catholic iron church of St Joseph at the Heath, and before that, bought for St Albans Splott in 1897 by the 3rd Marquess of Bute. So, by 1937 it had already seen long service. After the years of the Great Depression and war, the permanent church was consecrated in 1966, an avant-garde design with a central altar beneath a lantern, reflecting perhaps the era of 'Honest to God' Christianity, stressing the communal aspect of the mass. In 1992 the church façade (below) was enhanced by this beautiful bas-relief of a Calvary. Over the years the congregation dwindled, but in 2009, under the auspices of St Mark's, Gabalfa (see *page 33*), £80,000 was raised from several sources. The church was re-roofed, thoroughly renovated and rededicated by the assistant Bishop. Reflecting St Mark's evangelical emphasis, the interior has been reordered for multi-purpose use – 'Messy church' is very popular with the children – and has been renamed St Philip's community church.

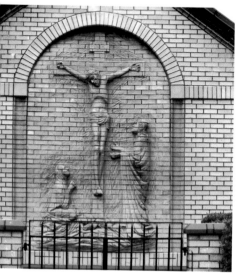

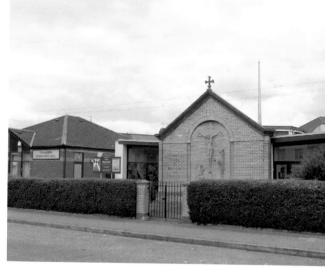

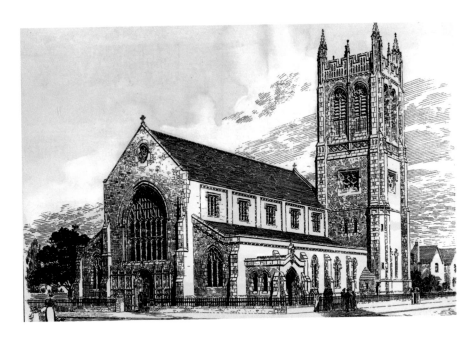

St Andrew & St Teilo, Cathays

If this design by George Halliday had been realised, the towered church of St Teilo would have rivalled St John's in the town centre. Sadly, the architect was over-ambitious, and to this day the tower is merely a stump. Built in 1897 for the railwaymen of Cathays and their families, it was nevertheless Halliday's *magnum opus*, or great work. Here are a huge arcaded nave with clerestory, the largest west window in the diocese, and an impressive raised sanctuary with crucifixion window by Kempe & Tower and idiosyncratic reredos. This priceless piece of Arts & Crafts is by John Coates Carter, formerly based in Penarth, and he sets the figure of Christ the Good Shepherd in a townscape familiar to the congregation. It is a unique piece, which merits careful scrutiny. Today the church is part of the Parish of Cathays, with St Michael's (*see page 31*), and prides itself on being an inclusive church welcoming people at all stages of faith. It is home to St Teilo Arts, a registered charity which opens up the building to the community for rehearsal, recording and performance. Many groups use the church, which has become known for the quality of its concerts and recitals.

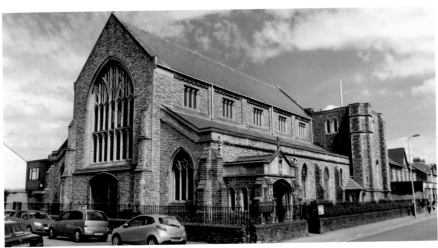

St Michael & All Angels, Cathays

The iron church (one of the 'tin tabernacles') was erected in 1922 in Whitchurch Road. It was the successor to St Monica's school/chapel of 1893 and served the working-class district in the north of St John's parish. This 'temporary' church lasted, through the Great Depression, the Second World War and the decline of the coal trade, for over seventy years. In 1995, the church found a development partner, and the valuable site now has flats for the elderly and a striking new church. With its steeply angled roof, triangular-headed windows and tastefully fitted interior, it makes a modern Anglican statement. On the mock tower is an acclaimed sculpture by Theo Grunwald, a pugnacious St Michael triumphing over the Devil. Today the church, along with St Teilo's, makes up the Parish of Cathays.

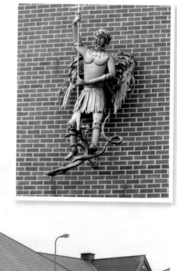

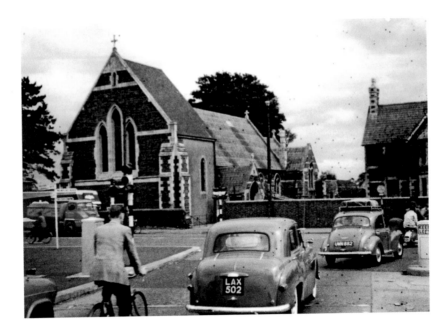

St Mark's, Gabalfa

Gabalfa means 'the place of the ferry', which before 1876 would convey people to worship in the cathedral over the river. Bishop Ollivant oversaw the new church of St Mark's, first as a schoolroom in Maindy, followed by the Early Decorated building (*above*) in North Road. The first vicar was John 'sporting Jack' Davis who rode to hounds – a very different area then! The church's style of worship changed in 1924 when Vicar J. C. Kempthorne Buckley arrived, and on his first day threw away the candles and the coloured stoles – with no word of protest? – and said, 'The average man does not want millinery and gymnastics with his religion; he wants a simple, straight Gospel message.' The evangelical ethos of the church was born, and St Mark's is still the only Anglican Evangelical Church in the Cardiff Deanery. The procession (*below*) shows a substantial choir of both boys and girls.

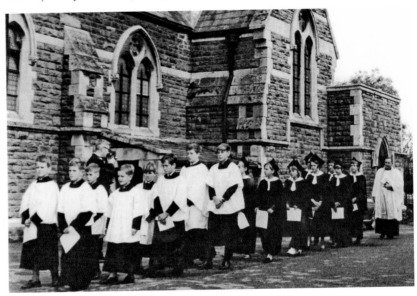

The 'New' St Mark's

Old St Mark's, along with 100 houses, a dance hall and a library, was demolished during the building of the Gabalfa Interchange 1968–71. April 1968 saw the last service in the old church and, within days, the first in the new. A pentagonal shape on ten frames of Douglas fir, with copper roof, lantern and detached bell tower at the entrance, it is very much a church for today. The picture (*right*) shows the Danish thirty-lamp brass candelabra above modern pews and an eastern altar. The old church lives on in retained war memorial windows and plaques, and a cross and candleholders were made from its old pine roof. The church today is a vibrant place, with Alpha courses and activities for young and old, and recently a school of Biblical preaching. The ethos of the church, unique in the Anglican Deanery of Cardiff, means that its congregation is drawn from across the city, well beyond parish boundaries.

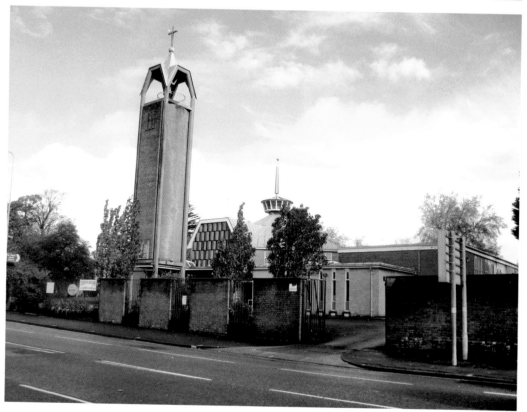

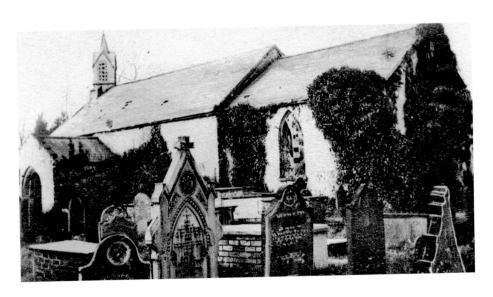

St Mary's, Whitchurch

Whitchurch is an old place, and was once completely separate from Cardiff. Its name no doubt comes from the little whitewashed church, which could have been here as early as the twelfth century. The old St Mary's church (*above*) is a seventeenth-century rebuilding, but this was replaced in 1884 by a church on a new site, a quarter of a mile to the west. The old building fell into disrepair and was demolished in 1904; the footings can be seen in St Mary's Gardens, showing a small nave, south porch and square chancel. The ground is lined with old gravestones. The new church (*below*) was built by John Prichard. It is 'a prim little church', says John Newman, set in a huge churchyard. Built of Pennant stone with Bath stone dressings with a tall thin tower, the rendered interior has a Prichard font, a lavish carved reredos of the Supper at Emmaus, and a variety of stained glass. St Mary's is the mother church of the Rectorial Benefice of Whitchurch, which includes St Thomas, Birchgrove, and All Saints, Rhiwbina.

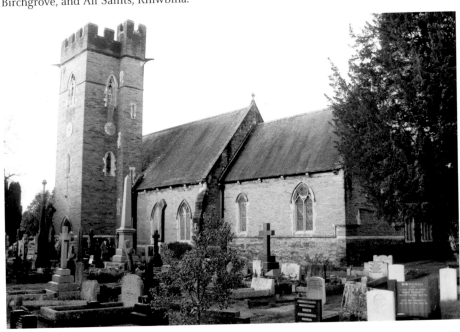

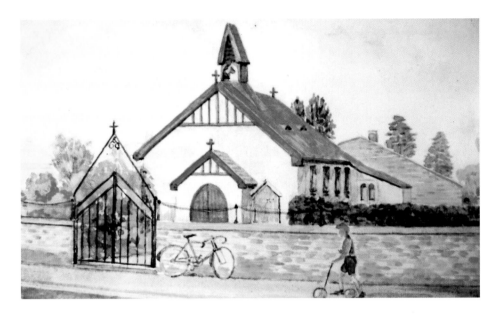

St Thomas, Birchgrove

The delightful old painting above dates from the 1940s and shows St Thomas, Birchgrove, the only one of the old 'tin tabernacles' left in Cardiff. They were not made of tin at all, but of corrugated iron galvanised with zinc. From the 1850s, these workmanlike buildings could be ordered from catalogues, often in flat-pack form, and many churches and chapels, here and overseas, were built very cheaply in this way. Most were temporary and often moved on to other locations when a permanent church was built, but St Thomas, never rebuilt, is still in use today. Previously used by Whitchurch hospital, the building was erected by the men of the parish on Pantbach Road in 1913 to seat 200. Chancel, vestries and a church hall were added later. The church is lined with tongue and groove boarding, with a cross-braced ceiling above, and has a modern wooden font and altar. Utterly simple, the little church, part of the Rectorial Benefice of Whitchurch, is a precious survival.

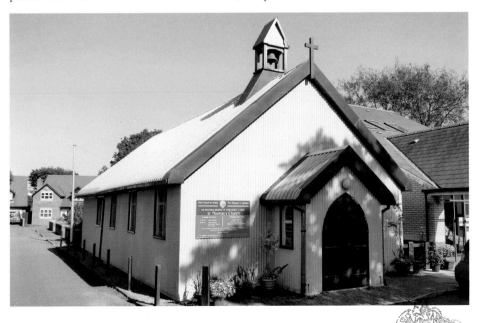

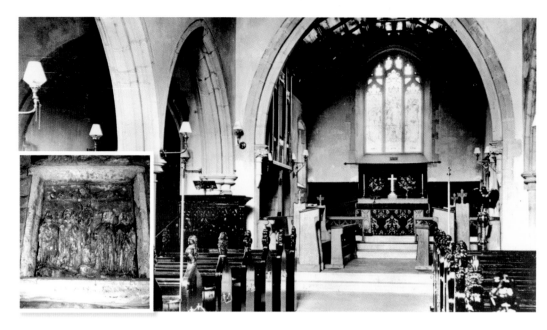

St Isan's, Llanishen

St Isan's church in Llanishen has a long history – Isan was a sixth-century saint – but it dates reliably from Norman times, when the dedication was to St Denys, patron saint of France. The fifteenth-century tower and medieval nave (now the south aisle) survive, as does a beautiful carving of the crucifixion over the old south porch. In 1908, a new nave, chancel and north aisle were added to create the spacious church of today, which is filled with stained glass and memorials. Llanishen grew enormously after 1871 when the Rhymney railway built the line from Caerphilly to Cardiff, passing through the village, during which work several men died and were buried in the churchyard. The railway created the commuter: a wealthy businessman could now reside in a leafy village and travel easily to work in town. The church, recently thoroughly refurbished, is lively and well-attended, and sits today in its capacious graveyard at the heart of what is now a busy, populous suburb.

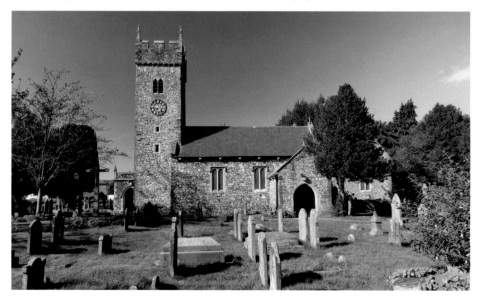

St Denys, Lisvane

St Denys, Lisvane, is one of the remaining old chapels of ease of St Mary's, founded by the Normans. The present building with its saddleback tower dates from the fourteenth century with later windows from a restoration of 1878. By then Lisvane was growing as a popular residence for those making money in Cardiff's boom times. Architect Edwin Seward – the Free Library, Royal Infirmary, Coal Exchange – built for himself the Arts & Crafts Lisvane House, and Ephraim Turner, builder of the City Hall, lived at Ty Gwyn. Substantial population growth in the 1970s meant the church was enlarged and reordered, with an oblique altar and sanctuary fittings by sculptor Frank Roper. Today, a vibrant church in a still affluent suburb looks out over farmland, as it has for centuries.

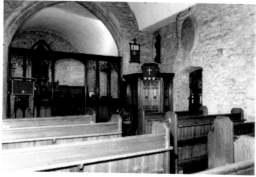

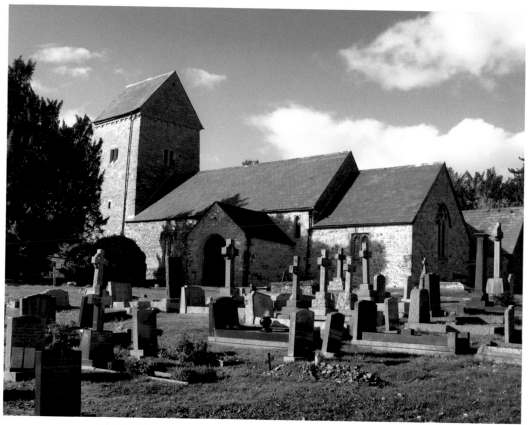

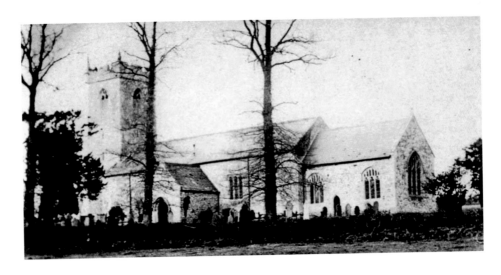

St Augustine's, Rumney

St Augustine's in Rumney is an ancient church, dating from 1108. It is the only Anglican church in this book that is in the Diocese of Monmouth, the River Rhymney being the boundary with Llandaff. Rumney itself was in Monmouthshire until it became part of the county borough of Cardiff in 1937. The west doorway from around 1200 is the oldest feature of the church; the nave, tower and chancel are somewhat later. There is quite a grand chancel arch, with evidence of an old rood loft, with some good Kempe glass and a striking modern baptistery window by Geoffrey Robinson (1976). Over the years there has been dispute about the church's dedication: is it to Augustine of Hippo or Augustine of Canterbury? If the former, the church may have been founded by the Augustinian Canons of Bristol. But these days, the first Archbishop of Canterbury seems to be favoured. The church has a peal of six bells, one from the reign of Charles II, and is known as a 'teaching tower' for ringers. As elsewhere in Cardiff, the area around the church has been transformed by housebuilding and traffic.

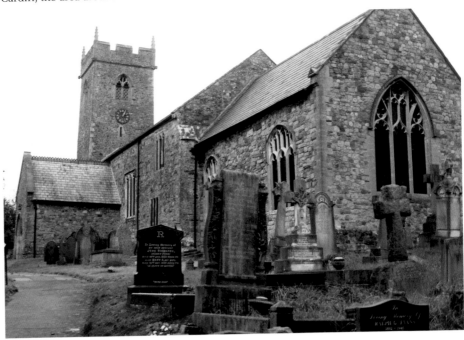

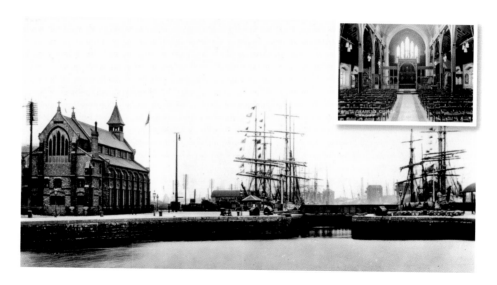

Missions to Seamen Chapel & The Norwegian Church

In the heyday of Cardiff docks, seamen visited (and often stayed and married) from all corners of the globe. From 1866, HMS *Thisbe* was moored in the West Dock and used as a Seamen's Mission, offering somewhere to relax and write letters home, as well as services and concerts. This was replaced in 1892 by a large chapel, All Souls (*above*), now demolished but which flourished until 1952.

The Norwegian church, built in 1868 beside the Bute West Dock and fish quay, served a similar purpose for Scandinavian seamen. It was prefabricated in Norway, with corrugated iron cladding and a beautiful interior. Its pastor had a manse at the top of Cathedral Road, which still survives as the hotel 'Prestegaarden'. Closed in 1970, the church building became derelict and vandalised, but was saved by a preservation trust whose president, Roald Dahl, had been baptised there. In 1991 the trust raised funds both here and in Norway for the church to be rebuilt on a new site on Harbour Drive. It is now a cultural meeting place, arts centre and café – an iconic building gracing the Cardiff Bay waterfront.

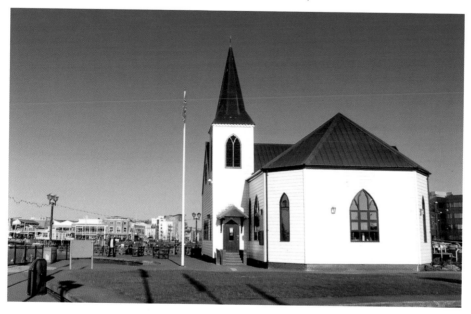

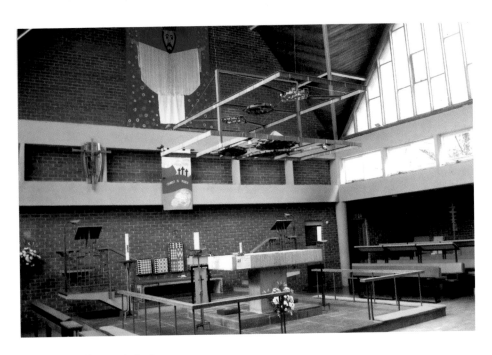

Christ Church, Roath Park

Christ Church, built in 1964 to the north of Roath Park Lake to serve the growing suburb of Lakeside, is in a modern design and is a product of the 1960s liturgical movement. It is a square open-plan structure, in grey-brown brick and glass, with a tent-shaped roof and soaring gables. A central sanctuary with a concrete altar sits below a metal-framed canopy with stained-glass downlights, a type of baldachin. This is by Frank Roper, as are the crucifix, font and much of the sanctuary furniture, cast in aluminium with angular bronze figures. Outside, another Roper work, his Creation plaque, stands behind the large Calvary and memorial garden.

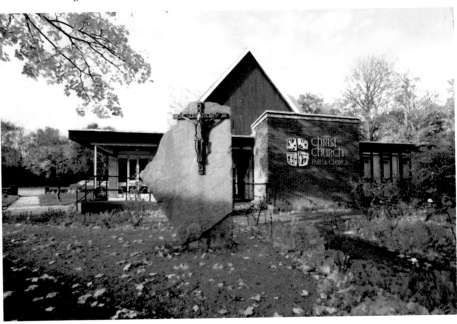

CHAPTER 3
Eglwys yng Nghymru
(Welsh-Speaking Anglican)

By the 1850s, there were several
chapels in Cardiff offering
services in Welsh, but in the
Anglican Church, Welsh would be
heard only in the outlying villages
of Rumney, Llanishen or Lisvane.
A curate at St Mary's, Butetown,
began to hold well-attended
services in Welsh in a schoolroom
but lacked the money to found
a Welsh-speaking church. To the
rescue came Sophia, Marchioness
of Bute, who funded the building
of Eglwys yr Holl Saint (All
Saints), Tyndall Street, in 1856.

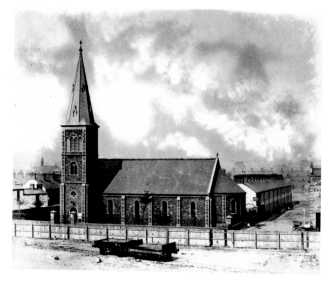

Architect Alexander Roos built
the well-appointed All Saints
church in Anglo-Norman style
with a 105-foot spire, but it had
a short life because of its poor
situation. It was hemmed in
by railways and docks, and the
local people were largely Irish
Catholic! There was no money
for a clergy house or stipend, and
by 1870 it had become a parish
church with services entirely
in English. Closed in 1899, it
was sold to the Great Western
Railway for £2,300; by the 1960s
it was an electrical warehouse
and was demolished in 1980. A
new All Saints (English) had been
consecrated in 1903 in Windsor
Place, but by the 1950s this too
was redundant. It became a
furniture saleroom and has now
been converted into flats.

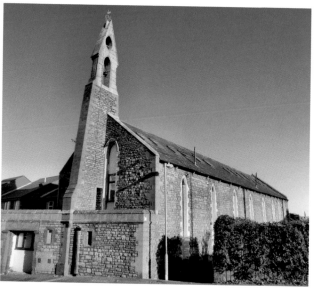

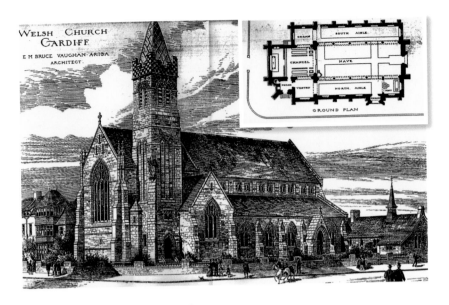

Eglwys Dewi Sant, Howard Gardens

The small Welsh congregation did not give up, however. They met for some years in houses until, in 1889, they were given land by Lord Tredegar for a chapel, Capel Dewi Sant, in Howard Gardens. Two years later, with generous donations, they were able to commission a new church adjacent to the chapel from architect Bruce Vaughan, whose design is shown above. Eglwys Dewi Sant was built largely as planned, in Perpendicular style with aisles, a tower, a spire, woodwork of oak and a reredos of Caen stone. An unusual addition was an immersion font. So the Welsh Church finally had a fine and suitable home, and here we see a large contingent of the church Lads' Brigade on parade in the gardens. Sadly the building was to last only fifty years, and was destroyed by enemy bombing in 1941.

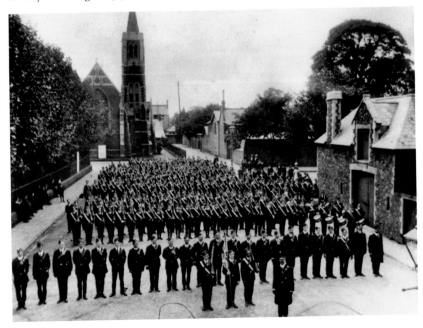

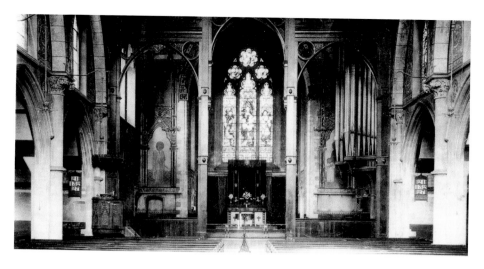

Eglwys Dewi Sant, Windsor Place

During and after the war, the church met in various locations, one of which was St Andrew's church in Windsor Place. This church, built to serve the expanding parish of St John's, was begun by Prichard & Seddon in 1860, but finished to a cheaper design by Roos in 1863. It became a separate parish in 1884, with St Teilo's, Woodville Road (*see page 30*), and in 1887 acquired a fine Father Willis organ. After the Second World War, its immediate area was no longer residential but commercial, and it made sense to transfer the church to St Teilo's. The building stood empty for two years, but after alterations – nave truncated to make a hall and rood screen relocated (and dynamite found under the lectern!) – it was reconsecrated as the new Eglwys Dewi Sant in November 1956. St Andrew still appears in the carved capitals of the nave, but the church has prospered in its new location, and is the only Anglican Welsh language church in the diocese. In 2009/10, a Heritage Lottery Grant and massive fundraising by the congregation enabled it to be re-roofed and restored. Sadly the Voysey murals, painted on walls and ceiling in 1888, could not be saved. The church opens one day a week to visitors, and is known for its series of recitals on the recently restored Willis organ. Below, a young family enjoys the sunshine at the church's 'island' location.

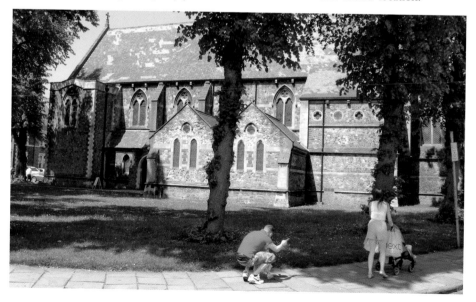

CHAPTER 4
Birth of Nonconformity

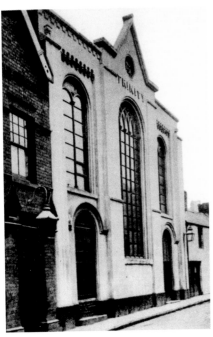

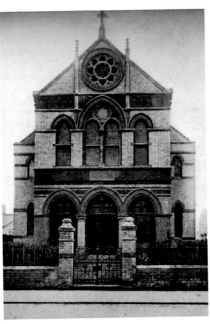

The first Nonconformists were probably the heretics, who, after the Reformation, were hanged or burnt at the stake for their faith. New ideas were a threat to the authority of the Church and the stability of society. In Cardiff, two men were burnt for their beliefs: Thomas Capper in 1542 and Rawlins White in 1555. These were individuals and founded no new church, but in the 1630s all that was to change...

At the parish church of St Mary were Vicar William Erbery, from Roath, and his curate Walter Cradock. They defied their Bishop by preaching, as he said, 'schismatically and dangerously'. They were the new 'Puritans', keen to purify the Church of anything but biblical doctrines. Both were ousted from their posts and went on to preach in London and to the growing Parliamentary party under Oliver Cromwell in the 1640s. In Cardiff, their ideas had taken root. Their followers and their descendants continued to meet in secret, until in 1697 they were given the freedom to build their own church – the first Nonconformist building in the town. They were anxious to show that their religion was purified but orthodox, and so they chose the name 'Trinity', for the plain little church in Womanby Street, opposite the castle. It burnt down in 1847, but undeterred they rebuilt with a fine classical frontage, the name 'Trinity' incised into the stonework.

The church's first pastor was John French, a Cardiff man who had been Vicar of Wenvoe, also expelled by the Bishop. The land was held on a 999-year lease, with a rent of just one penny paid to Alderman John Archer, who became their second pastor. He bequeathed to the church a silver communion cup dated 1637, which is now on display at the Welsh National History Museum at St Fagan's. But the congregation started to dwindle. Womanby Street was a narrow, by now insalubrious, byway, and the church was next door to two pubs, the Red Cow and the Horse & Groom! It was not ideal for good Nonconformists, who abhorred the demon drink. Many members had moved out of town to the suburbs, and in 1889 Trinity was amalgamated with Llandaff Road Congregational church in Canton to form New Trinity, a handsome brick building on Cowbridge Road.

CHAPTER 5
The Independent/ Congregationalist Church

A Welsh-speaking group from Womanby Street in 1826 rented a coach house in Temperance Town – the site of the bus station – and in 1828 moved into a chapel on a site in Paradise Place, behind the present-day Queen Street. This was Ebenezer, which means 'hitherto hath the Lord helped us', and was the first Welsh Independent (Annibynwyr) chapel in Cardiff. (The English chapels would call themselves Congregationalist, but the Welsh tended to stick to Independent.) The first minister, Lewis Powell, worried that it was too far away from the town and spent long hours begging money to help pay for it. From the 2nd Marquess of Bute he received courtesy but not a penny. The chapel was rebuilt in 1852. It was a commodious, if not elegant, building.

Paradise Place is long gone, along with the old Ebenezer chapel. In the 1970s, big plans were afoot for a new St David's shopping centre in Cardiff, and much of the area south of Queen Street was subject to compulsory purchase. Ebenezer was relocated to the building previously occupied by Charles Street Congregational church (*see page 47*), where it remained until 2011, when repair bills and problems with city centre parking became so acute as to necessitate a move. Ebenezer still thrives, but now meets in the new church centre, Whitchurch, on Sunday morning and in City church, Windsor Place, in the evening. The old site of the church is under the huge shopping mall of St David's Centre, and only this plaque recalls where it once stood The plaque reads: 'Near this spot stood EBENESER Welsh Independent chapel 1828–1978.'

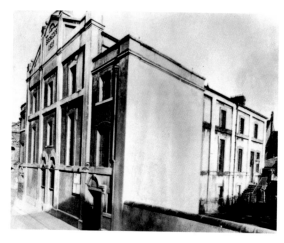

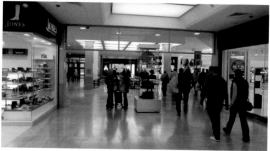

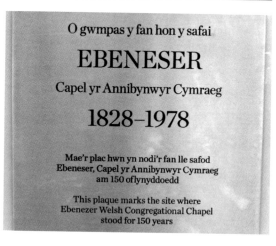

O gwmpas y fan hon y safai

EBENESER

Capel yr Annibynwyr Cymraeg

1828–1978

Mae'r plac hwn yn nodi'r fan lle safod Ebeneser, Capel yr Annibynwyr Cymraeg am 150 oflynyddoedd

This plaque marks the site where Ebenezer Welsh Congregational Chapel stood for 150 years

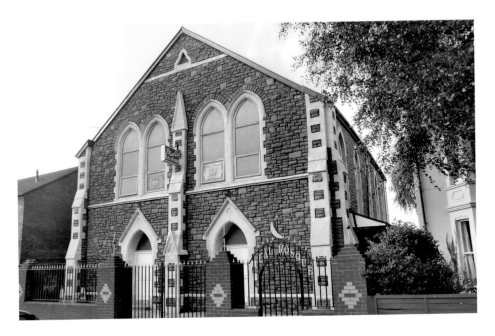

Severn Road & Minny Street Welsh Independent

Welsh Independent chapels have had mixed fortunes: the one shown above, in Severn Road, Canton, was founded in 1868 by a group from Ebenezer who lived to the west of the town. Very soon some members left, wanting services in English, and set up in a former Methodist building in Llandaff Road, now Canton Gospel Hall (*see page 86*). The Severn Road chapel finally closed in 1980 and from 1995 has been a Bilal mosque, the Madrasa Talim-ul-Quran.

A Welsh Independent that flourishes today is in Minny Street, Cathays, founded by sixty-eight members from Ebenezer in 1884, to serve a working-class district with large numbers of railwaymen. The fine chapel was built in 1887, rebuilt in a Lombardic Romanesque style (John Hilling) in 1904 and restored in 1927. Today the church thrives, with active children's and youth work, and flies the flag for Welsh Independency on the east side of the city.

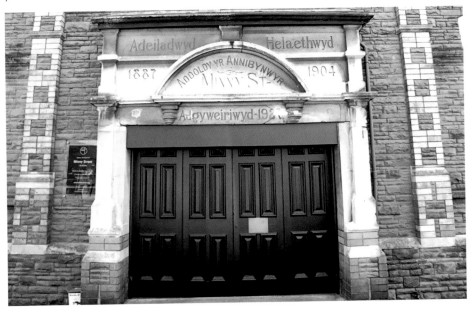

Charles Street English Congregational Church

This church became one of Cardiff's most prestigious, founded from Trinity in 1855. Built of multicoloured stonework brought as ballast in Cardiff ships, it is 'a lesson in theology and geology'. The lavish Gothic style, with carved angels and stained glass, had Catholic associations and was a new departure for Congregationalists. Charles Street, a fashionable area with large houses, meant pew rents were set at 2s 6d per quarter. But it was 'hemmed in by vile slums'; new members were strictly vetted, and could be expelled for undesirable conduct or intemperance! It merged with Wood Street in 1971 and, with the formation of the URC in 1972, was amalgamated with Windsor Place English Presbyterian (*see page 74*), moving into the latter's building. It rehoused Ebenezer from 1977–2012, when it was sold to the Archdiocese of Cardiff and became 'The Cornerstone at St David's', a community facility for the Roman Catholic Church. Below, a grainy old picture of Charles Street in its congregational heyday.

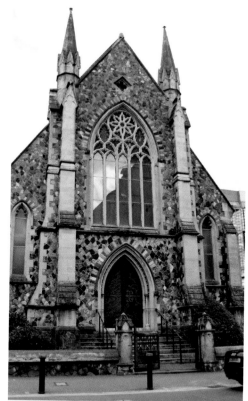

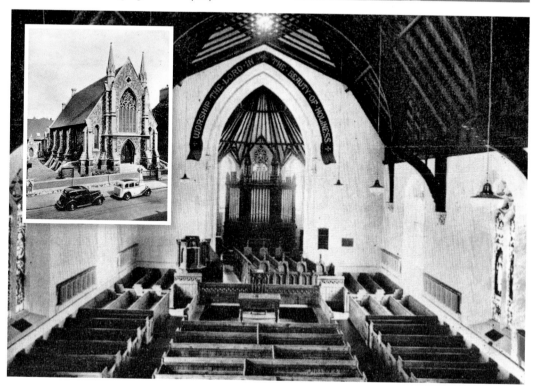

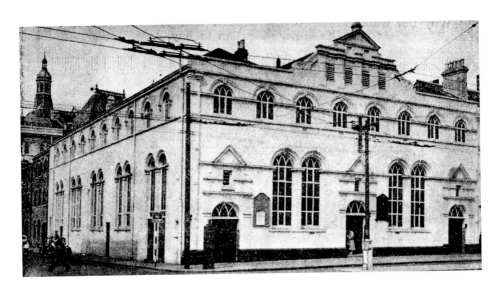

Wood Street Congregational Church

Wood Street was the most famous chapel in Cardiff, attracting huge congregations, and, on one occasion, a sensational scandal. The building began life as a temperance hall, then a music hall and later a circus. By 1868 it was a 'white elephant', and Pastor William 'Pop' Watkiss from nearby Guildford Street United Methodist Free Church set his sights on it as a venue to pack in crowds of unchurched working people. On the strength of the expectations of Mr Ashton, a prominent member of his congregation, the building was purchased, members lent their savings, and Cardiff's shops gave the Ashtons endless credit. When the time came to claim the inheritance, Ashton simply disappeared. He left behind £3, a carpet bag and an old coat. The church was devastated, and the newspapers had a field day – religious people 'seduced by the golden calf'. A revue telling the story was staged at the old Theatre Royal and played to packed houses! Fortunately, Hannah Street chapel in the docks and generous individuals came to the rescue. Wood Street was saved and Watkiss went on to have a long and successful ministry, with over 2,000 people at evening services. But wars and depression meant decline; Temperance Town had been flattened in the 1930s, and the old chapel was finally demolished in 1973 and replaced by office buildings. In its heyday, what a grand interior.

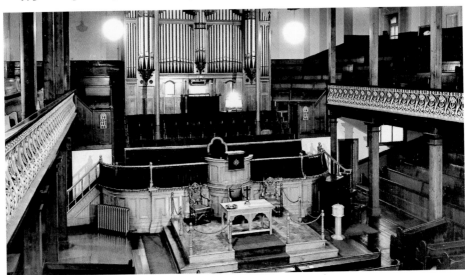

Star Street, Hannah Street & Parkminster

Star Street Congregational was opened in 1871 in a backstreet of what is now Adamsdown (then Splotlands), creating a Congregational/Independent presence in this growing area of Roath. In the early years, problems with attendance and especially finance led to a breakaway group setting up in Stacey Road, but that disbanded in 1916. The 1880s were a time of revival, under Minister Sinclair Evans; the chapel was full, and 'moved in a glow of great prosperity'. Seat rents were contentious, however, and members left when the minister did. Renovation came in the 1890s, and all seats were made free once a month. Sunday school, Band of Hope (temperance), Reading Circle and Boys' Brigade are evidence of a vigorous church life, and indeed, in 1927 the church built a hall in Minster Road Roath, the beginnings of a new church 'plant'. Star Street still flourished up to the 1970s. Ironically, when Star Street closed in 1985, the congregation joined that of its 'daughter' Minster Road URC, now Parkminster. The old Star Street building is now the Sikh Gurdwara Nanak Darbar.

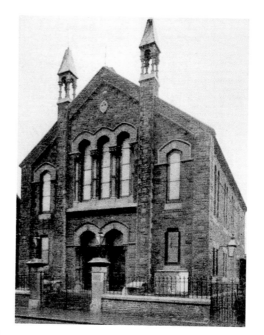

Churches of this denomination have had mixed fortunes: Hannah Street in Butetown was built in 1868 on Bute land, a 'handsome edifice' in Classical style with Corinthian columns and massive pediment. It seated 700 and cost £4,150, a vast sum at the time. The fundraising took its toll on Pastor John Davis, who died in 1874. The newly wealthy were moving out of Butetown to the suburbs, and the population was becoming multiracial. The chapel struggled, and eventually had to sell its building in 1917 for £1,500, the few faithful members continuing to meet in a house in Patrick Street. The chapel building had a reprieve in 1932, when for a while it served as a church for Finnish seamen. It was finally demolished in the 1950s.

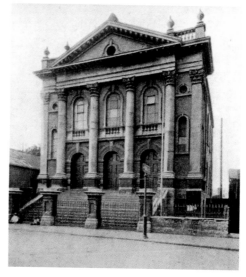

Parkminster, the former Minster Road URC, is a survivor. Initially a plant from Star Street, it absorbed its mother church in 1985. It became a joint pastorate with Roath Park URC (*see page 50*) in 1996, and, after the sale of the Roath Park building, the two churches with the new joint name combined in 2008. Parkminster now thrives, with an array of services and group meetings and, with the proceeds of the Roath Park sale, has undergone extensive renovation and updating, completed in September 2012.

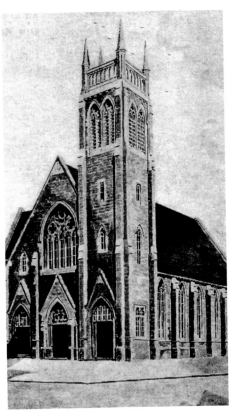

Roath Park Congregational Church

Roath Park Congregational church was founded in 1897 as an iron building in Mackintosh Place, followed in 1910 by the grand structure seating 650. In early days they struggled to pay the Minister's stipend, but steady growth soon followed, with membership passing the 400 mark by 1920. The church was open every day for various groups, and early arrival on Sunday was needed to secure a seat. Bomb damage in Second World War necessitated refurbishment, including the removal of the pinnacles on the tower roof. But community service, particularly with the young, failed to halt the decline in congregations. In 1972, the church became Roath Park United Reformed church, but the cost of major repairs in the 1990s made it difficult to support a full time minister. Roath Park and Minster Road URCs first shared a pastor, and then were finally merged in 2008, with the Roath Park building put up for auction. In 2009, the building was bought by Tabernacl, a splinter group from Heath Evangelical church (*see page 73*). Much restoration has been done and the church, based on strong Biblical teaching, is once again thriving.

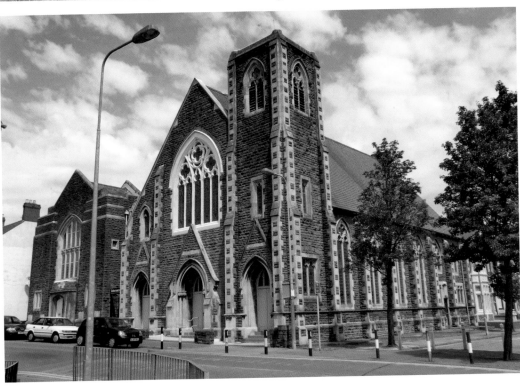

Beulah United Reformed Church (URC), Rhiwbina

Beulah URC, Rhiwbina, began life in 1849 in a rural, Welsh-speaking area. A long-walled chapel opened at the crossroads in 1851 and was extended after the Revival of 1859. By 1891, with growing membership, a new chapel building opened on the opposite corner (*seen above right*). The old building became the Assembly Rooms. Today it is the Canolfan centre and is open every day for church and village activities. In 1904, worship in Welsh gave way to English, and Beulah became an English Congregational church and then a URC in 1972. The church has always been active in refugee work overseas, and today Kindred in Need (KIN) raises large sums for charities at home and abroad. The back of the church was developed in 1992 to create the Whittaker Lounge, used by groups and as a weekday morning coffee shop. The Canolfan Beulah opened at the Millennium; thoroughly modern, though retaining the old chapel façade on the Beulah Road side. A hub of village activity, it is enhanced by vibrant modern artwork. Behind, the old graveyard has been made into a 'garden of life'. It is a lovely space for reflection, with the original graves listed on the wall. Beulah is a thriving church, and its worship is liberal and lively, offering care and compassion to all-comers.

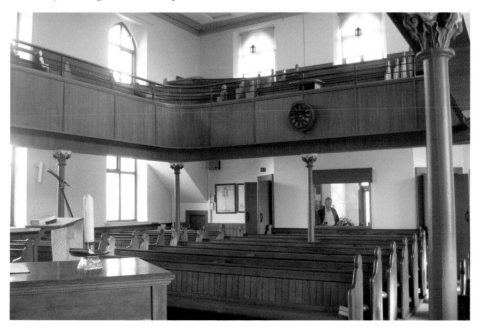

CHAPTER 6

The Baptist Church

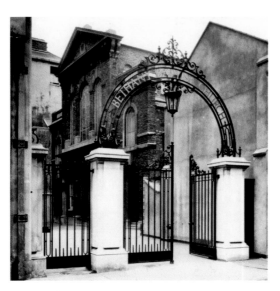
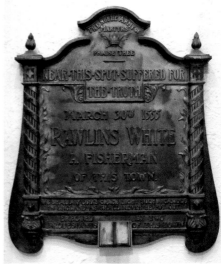

The Baptist Church practises baptism by immersion, as the baptism of infants is not scriptural. Baptists first appeared in England in 1612 and in Wales by mid-century; 150 years later they reached Cardiff, with the baptism of three Herefordshire people in the River Taff in 1806. They met in two rooms, then in a stable with a garden, where member Thomas Hopkins buried his dead child; it was the first burial in Cardiff in unconsecrated ground. 'The Saviour lay in a garden', he said. The 1816 chapel held the first Sunday school in Cardiff. Enlarged in 1840, it was rebuilt in 1865 in grand Lombardic style by John Hartland. By the 1950s, it was surrounded by shops and offices, and the congregation dwindled. Howell's store, which virtually enclosed it, purchased the building, preserving the arcade arches, the apse and the west frontage (*below left*), still on view to shoppers today. The plaque above commemorates the burning in 1555 of 'heretic' Rawlins White. The payment from Howells enabled the purchase of a greenfield site in Rhiwbina, and in 1964 came a building in 1960s 'extravagant architecture', with an undulating roof over gabled windows and a dramatically painted interior. A baptismal pool, a marble pulpit and brass plaques recall the old chapel.

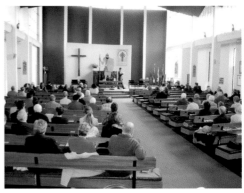

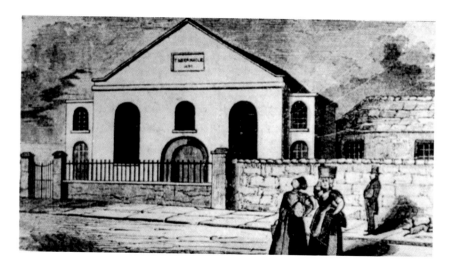

Tabernacl Baptist Church

Tabernacl ('a tent') in the Hayes is the oldest Baptist chapel in the city still on its original site. A Welsh-speaking group from Bethany formed a new church in 1813, beginning in a public house, but by 1821, with 100 members, they built a single-storey chapel in the Hayes. This was replaced in 1865 by the present classical building, seating 900. With four arched doorways below round-headed windows, between Corinthian pilasters, and a balustraded balcony, this chapel façade, says John Harvey, 'was a billboard announcing that Nonconformity had arrived'. Inside, a handsome galleried interior has large central pulpit with '*set fawr*' (big seat) for deacons and unseen baptistery beneath. The fine 1907 three-manual organ was refurbished in 2010. The church has many claims to fame: an early Minister was Christmas Evans, 7 feet tall and one-eyed, whose sermons reached America; the first ever *Songs of Praise* (1961) was held here, and the Welsh National Millennium Service in 2000; and a wooden plaque, rescued from a rubbish tip, was carved by Welsh prisoners of war in Changi camp, Singapore, in 1943. The church feeds the homeless every Sunday, and hosts 'The Christmas Story' to full houses throughout December. They work tirelessly for charity, and have built and maintain a health clinic in Lesotho. Below, people shop, eat and relax against the backdrop of this fine old building.

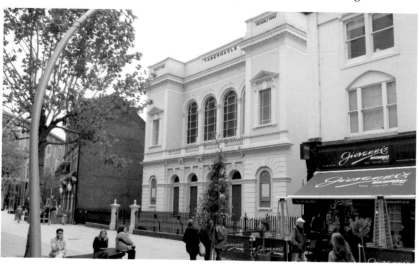

Llandaff Road Baptist & Canton Uniting Church

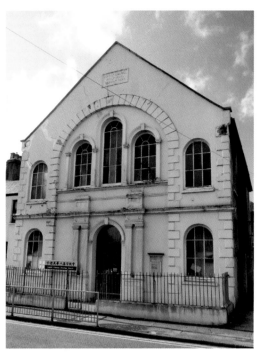

Llandaff Road Baptist (1853) was the first place of worship in Canton. Its most famous Minister was Revd Robert Lloyd, the 'Apollo of the Welsh pulpit'. Changes came later – services in English and then Canton's first woman minister, Revd Julie Hopkins. After joining with New Trinity (*see page 44*), the Llandaff Road building is now Cardiff's Chinese Christian church. Canton Uniting church in Cowbridge Road is a union of New Trinity URC and Llandaff Road Baptist, the two denominations coming together in 1995. Committed to ecumenism, it has a varied congregation and people are accepted regardless of belief or sexual orientation. Gatherings are also held with those of other faiths. The striking modern building on New Trinity's site is used by many groups, church and otherwise. It is a church at the heart of its community.

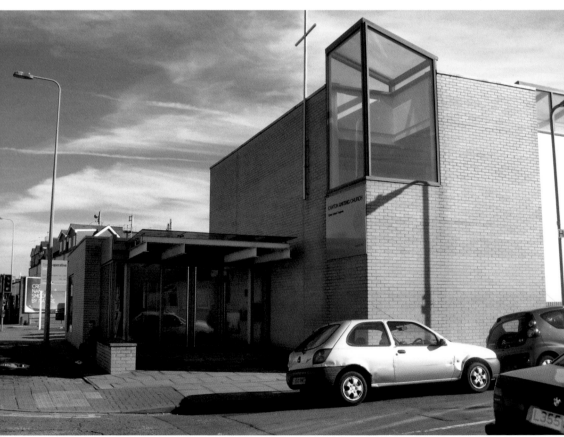

Calvary Baptist Church, Canton

Calvary Baptist church in Cowbridge
Road has an interesting history. It began
as Hope chapel, an offshoot of Bethany,
in 1858, for English-speaking Baptists in
Canton. Bethany gave £600 of the £1,100
cost. The building was in Lombardic
style, using variegated stones, and was
designed by Habershon & Fawckner.
As the photograph (*right*) shows, it
had an imposing appearance, slightly
modified from the architect's original
concept. Inside, the elevated chapel, with
ornamental table, platform and baptistery,
had 'commodious' schoolrooms beneath.
Despite this, a larger 'church' was built
behind it in 1880 (today the schoolroom).
In 1936, the chapel was demolished and
a new building opened on the site in
1937. Hope lasted until 1971, when it
amalgamated with Victoria Baptist in
Riverside to form the new Calvary. The
Victoria premises have become Shiloh,
a Pentecostal fellowship, and Calvary
has been progressively modernised,
culminating in the new foyer and glass
frontage seen today – a long history for a
modern vibrant church.

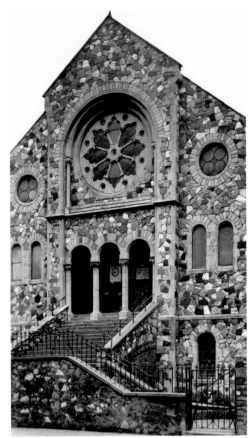

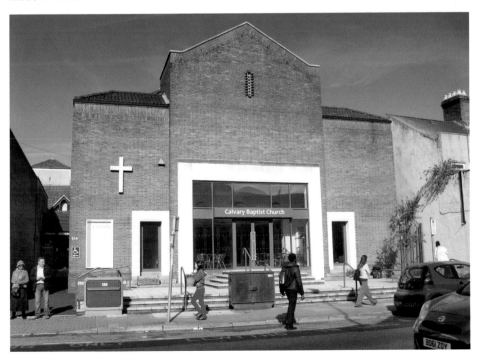

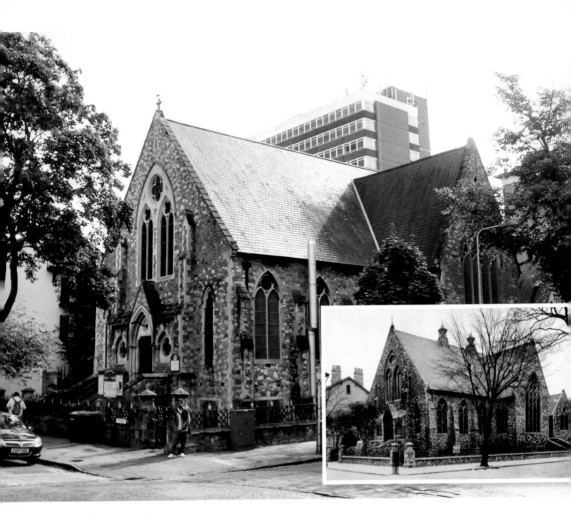

Tredegarville Baptist Church

Tredegarville Baptist church in the Parade was another offshoot of Bethany. Revd Alfred Tilly, minister at Bethany, left in 1861 with 111 members, to found a cause to the east of the town. They began in rooms in Castle Road (City Road) and moved into the present building a year later. The land was given by Lord Tredegar and built by his estate architect W. G. Habershon in Early Gothic style with cruciform plan (on Lord Tredegar's orders). The 'pepper & salt' limestone came as ballast in Cardiff ships, probably from Galway (John Newman). By 1865, the fully-fitted chapel, with schoolroom and vestries, was complete and paid for (£3,600). Tilly was nicknamed 'prince of beggars', and large donations were made by the Cory shipowning family. An Evangelistic Church, it founded several 'stations' in the eastern suburbs and sent missionaries abroad. It was also the venue for founder of the Salvation Army General William Booth's first worship service in Cardiff in 1863. The fine interior, with its arcaded stone baptistery, three galleries on iron shafts and plentiful stained glass, today houses 'Tredegarville International church'. People from eighty-four nations attend its services. Missionary work in Zambia and Uganda still goes on, and the church thrives, especially with its ministry to young people of all nationalities living and studying in Cardiff.

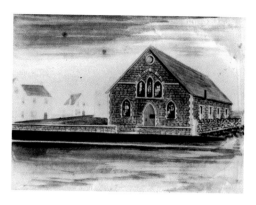
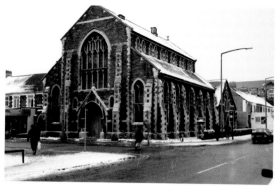

Woodville Road Baptist Church

Woodville Road Baptist church began when groups from Bethany and Tabernacl in town cast their eyes on Cathays, seeing the rows of terraced houses going up on what had recently been farmland. They met (appropriately) in an upper room at the town end of Cathays Terrace but built a schoolroom in Fanny Street in 1881, and the church was founded with thirty members. A year later membership had doubled, with 260 in the Sunday school. The main church building came in 1887, and galleries were added in 1892. A pipe organ and a young men's institute followed, and organisations for all ages made for a lively church. In 1904, the year of Revival, over 100 baptisms took place. In the Second World War, the church escaped significant damage. The schoolroom, after two years of use by the Army, provided a very good Canteen Service where hundreds found rest and refreshment. In the 1920s the church was often filled, and the Sunday school peaked at 611 with 45 teachers. Over the years the building deteriorated and in 1990 a gale removed part of the roof. Despite repairs, the church decided the building should be demolished in 1993 and replaced by one more suited to the present day. In 2002, the new church, now facing Crwys Road (*below*), opened, with a Spar shop renting the ground floor corner and meeting rooms above. Today, the renamed Woodville Christian Centre is a lively modern church with activities for all ages and is very popular with students.

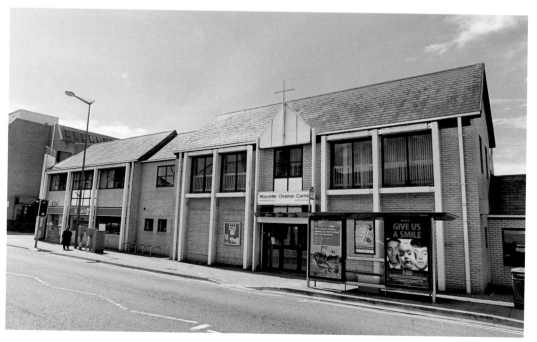

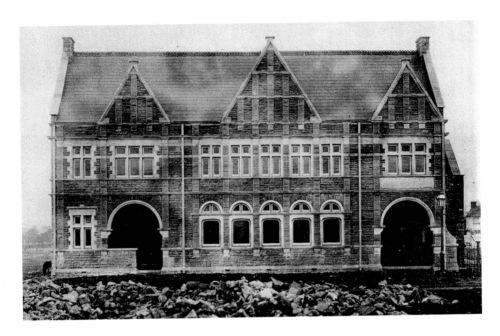

Albany Road Baptist Church

The cause began in 1894 above a stable in Cottrell Road, with the occasional neigh punctuating the sermon! It began as Particular Baptist: no one involved in the drinks trade could be a member, and Communion was open only to those baptised by immersion. In 1898 a school chapel opened in the fields on what became Blenheim Road. The large building (*above*) is in Renaissance style, and held chapel, vestry, and classrooms. The adjacent corner site was left for a future church, which they were determined to open free of debt. A 'South Pole' Bazaar in 1910 raised £744. In 1916, church became 'open communion' – a sign of the times. The new chapel was delayed by war and lack of money. Opened in 1932 and made of brown brick and Bath stone, its Perpendicular tower was never finished. Spacious, with central aisle, north pulpit and gallery, a glass frontage and vestibule were added in 1994. Below, the 1932 church on the corner of Albany Road can be seen, with the old schoolroom, still fully used, sitting behind.

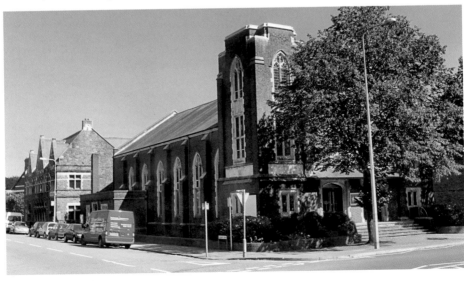

CHAPTER 7

The Methodist Church (Wesleyan)

 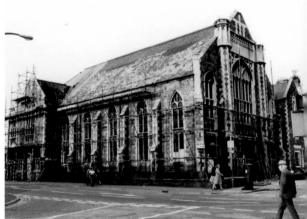

John Wesley, the founder of Methodism, lived and died an Anglican priest, and it would be his followers who formed a separate church. Along with his brother and friends, he started a 'holy club' in Oxford, whose methodical way of life earned them what began as a nickname. He believed in 'a religion of the heart', and felt that the cool eighteenth-century Church of England had strayed from important beliefs like justification by faith, assurance and perfectibility. It neglected to address the needs of vast numbers of unchurched people flocking to the towns and cities for work in the new industries, and Wesley set off on horseback to preach all over England and Wales to vast crowds in the fields and marketplaces. His 'Methodists' would spearhead the Evangelical revival.

Wesley first visited Cardiff in 1739 and preached in the Shire Hall, as the vicar of St John's would not allow him to preach in the church on a weekday. (Undeterred, he returned to Cardiff on fifty occasions up to 1788.) It is thought that he opened the first 'New Room' in 1743, probably in Church Street. The cause grew, and by 1796 had 200 members and three ministers in the town. In 1829, their premises were rebuilt, and the upper part of the building with its date can still be seen today.

Despite its humble building, the Wesleyan cause was embraced by many of the town's prominent and wealthy families, and in 1850 a grand new Gothic chapel, the Wesleyan Central Hall, opened on the corner of Charles Street. The architect was James Wilson; it seated 1,000 people and cost, along with school and manse, £9,000. Many of the nouveau-riche Cardiff businessmen were Methodists and dug deep into their pockets. In 1894 it was destroyed by fire, on Good Friday of all days, but was rebuilt (as in the photograph) a year later. As the city centre lost its residents to the suburbs, the congregation dwindled, and the church closed in the late 1930s. The building was sold, becoming a labour exchange until 1941, then a storage facility for the Welsh National Opera until its demolition in the 1980s. It is now the site of the Jobcentre. The money from the sale of the building helped to build new churches in the suburbs, including that in Fairwater in 1959.

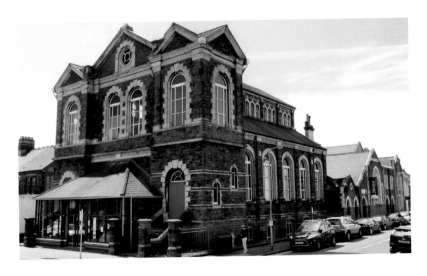

Cathays Methodist Church

Eight years after the new Wesley chapel opened in town, a Mrs Edwards started a Sunday school upstairs in her house in Cathays Terrace. Six people attended; one, aged eighty-eight, had to be carried up the stairs. From this tiny beginning grew the cause that became Cathays Methodist church. By 1901 it had huge evening congregations and a Sunday school of over 900. A school chapel had been built in Fanny Street in 1883, followed in 1890 by the chapel next door, on the present corner site in Crwys Road. It was a lavish structure in Romanesque style with bulbous twin tower turrets at the corners (now gone). In 2006, the building was reordered horizontally, with the sanctuary at the top, a large hall on the upper ground floor and three meeting rooms below. A glass-fronted porch creates a welcoming entrance. It is an active church, attracting many students, with groups meeting during the week and rooms hired out to the community.

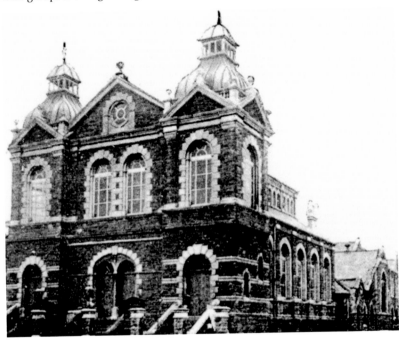

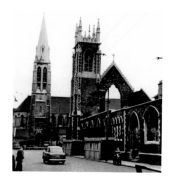
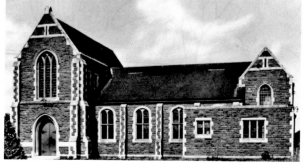

Rumney Methodist Church

Roath Road Wesleyan Methodist church, one of the most important Methodist churches in Wales, began life as a mission room and was then a school chapel until the grand towered and pinnacled building (*seen above left*) opened in 1871. When Roath Road became Newport Road, the chapel retained its name. Chapel, school and manse cost £12,000, paid for with the help of John Cory and Solomon Andrews. All good work ceased when the building was badly bombed in 1941 and its shell was demolished in 1955. Behind it is the church of St James the Great, a daughter of St John's. The finest work of architect Bruce Vaughan, it closed and was sold at auction in 2007. A listed building, its future now seems uncertain.

Monies received from the War Damage Commission enabled the building of several suburban churches, including Rumney Methodist church. A chapel had opened on the village green around 1814, its location given as Tredelerch, Welsh for Rumney. English replaced Welsh around 1900, and in 1929 a larger school/chapel opened in Wentloog Road. After the Second World War, a new council estate meant many more people in the church, and with the compensation money a new church and classrooms were built in front of the chapel, then used as a hall. The new buildings proved less durable, however, and with extensive fundraising and a Welsh Assembly grant they were demolished. The old chapel was fully refurbished, with a new worship area and meeting rooms. As a condition of the grant, the local community now shares the church's excellent new facilities.

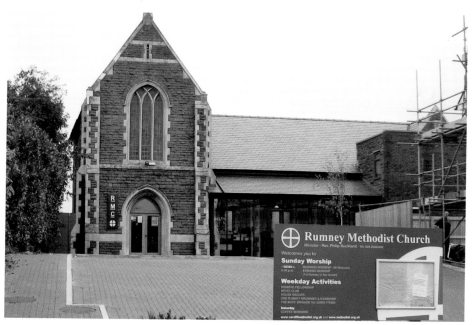

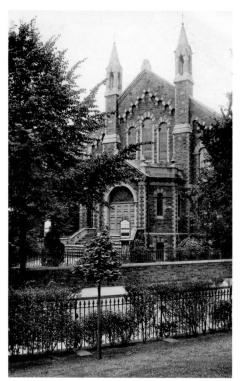

Conway Road Methodist Church

Conway Road Methodist church is one of Cardiff's finest chapels, known as 'the Cathedral of the denomination'. But it began humbly in 1859, in a plain, long-walled building in Romilly Road, and was later sold to Congregationalists and then to the Brethren. With the help of £700 from coal magnate Lewis Davis, however, this magnificent chapel was built in 1869, rearing up over the road junction at Romilly Crescent. Its polychromatic façade expresses 'the confidence of a prosperous congregation' (John Newman). Rich patrons attended Conway Road, and in 1893 the Wesley Centenary School opened for, ambitiously, 700 Sunday scholars. By the 1930s they had 900, with 100 teachers, and tennis courts and a cricket field were acquired in Fairwater. Today numbers are fewer, but the fine building is a reminder of the grandeur of the chapels' heyday. In the summer sunshine, its multicoloured stonework and brightly painted door make as dramatic a statement as ever.

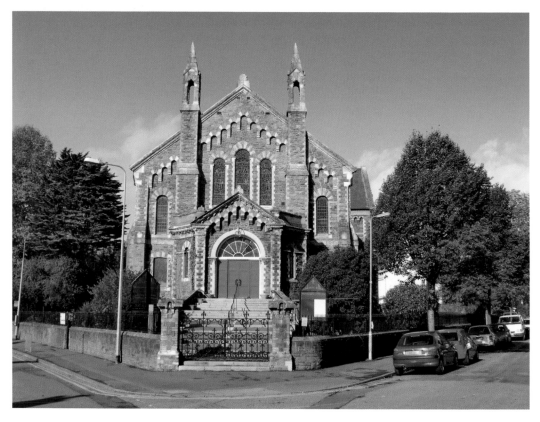

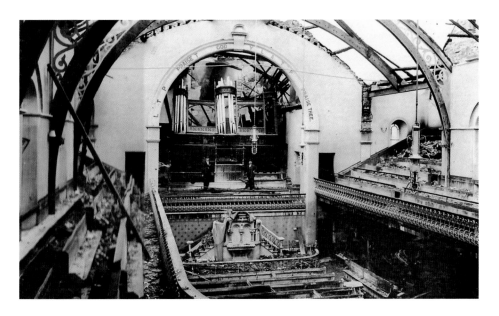

Conway Chapel Interior

This fine photograph shows church members standing amid the wreckage of Conway Road chapel after the fire of 1915. The organ was badly damaged and the fine Arts & Crafts roof destroyed, but the church rose from the ashes, and a new roof was built in mock-Georgian style. A magnificent organ and galleries adorn the interior, the latter supported on giant cast-iron brackets. The pulpit survived the fire, being, unusually for a chapel, a fine Romanesque design in stone. In 1968, the Sunday school building was sold to the Welsh League of Youth, the Urdd, and the basement and rear of the church was developed to create, in true Wesley style, a 'New Room'.

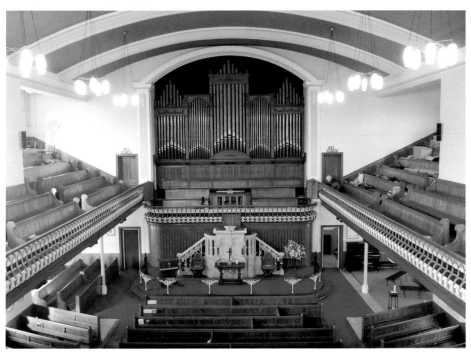

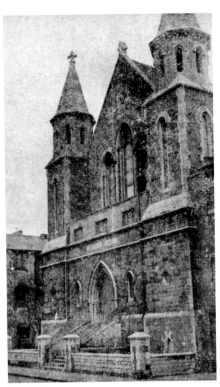

Loudoun Square & St Paul's Methodist Churches

The first offshoot of Charles Street Wesley, Loudoun Square Methodist church opened in 1860, with twin turrets, a stone staircase and seating for 600 people. An important church, in fact the 'mother' of the far grander Conway Road, it declined with the changing face of Butetown and, unable to support a minister, became a 'mission' in 1893. The grainy old photograph probably dates from soon afterwards. By 1933 the church declined, and was refounded as 'Cardiff Coloured Mission'. During wartime a rest centre fed and clothed the homeless, and films were shown in the chapel. An old Army hut was re-erected at Trellech, where docks children were given a rare holiday. But money was always tight, and with the compulsory purchase order in the 1960s came relief, and the possibility of a new building following the redevelopment of Butetown.

The renamed St Paul's community church was consecrated in 1966, with George Thomas, later Lord Tonypandy, reading the lesson. The church today contributes to ecumenical and inter-faith work in the religious diversity of Butetown and the Bay.

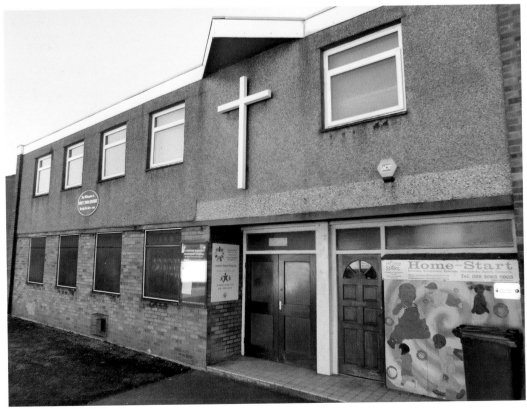

Ely Methodist Church

Ely Methodist church began very early, in 1806, as a Welsh-speaking cause in a converted barn in Mill Road. Substantial alterations were made in 1843, and from about 1858 both English and Welsh services were held. Because of the growing membership, the building was demolished; and a new chapel, seen on the right, was built on the same site in 1857. With increased prosperity, it moved to a prime site at the junction of Cowbridge Road and Colin Way, where the building, costing £2,894 and seating 800, opened in 1911. In quite an elaborate Perpendicular style, it has aisles and clerestory, cast-iron arcades and a west gallery with serpentine balcony front (John Newman). After many years of patching and repair, the schoolroom was demolished in 1975 and the chapel was altered to combine church and community hall in one. George Thomas, Methodist stalwart, came to unveil the plaque. The church celebrated its centenary in 2011.

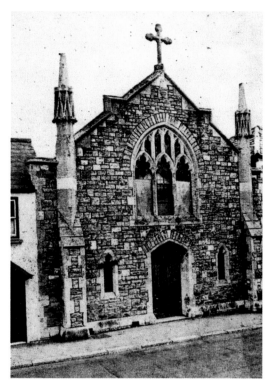

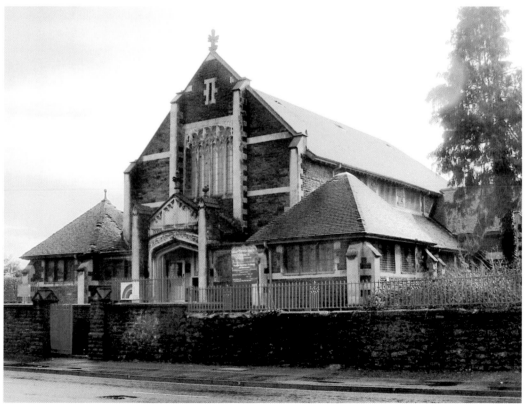

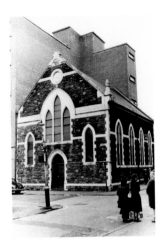
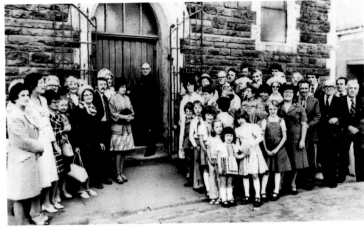

Bethel Welsh Methodist Church

Welsh-speaking Wesleyans at first worshipped with their English brethren in Charles Street, but separated to a site on the canalside until 1838, when a new chapel, Bethel, was opened in Union Street (*seen in the picture above left* © Media Wales Ltd). It was later enlarged and a gallery and organ added. In the 1970s, Cardiff Council planned the St David's shopping centre, and many of the streets of the warren to the south of Queen Street, along with their chapels, were served with compulsory purchase orders. Bethel closed in August 1977, and the above photograph shows the minister Revd Lloyd Turner closing the doors for the last time. There is nothing today to mark the site of Bethel, which was behind the present British Home Stores.

For five years, the congregation worshipped in the Unitarian Chapel in West Grove (*see page 89*) and in 1982 moved to Rhiwbina to share a 1927 chapel, also Bethel, with an English-speaking congregation. In 1991 the English group, now very small, decided to disband, and the chapel, benefiting from the compensation money, has been extensively renovated. It now has a membership of fifty and a strong Sunday school. Today, it shares a minister with Salem, Canton (*see page 70*) – the Welsh-speaking aspect overriding the denominational difference. Below, the Rhiwbina chapel with its signboard; note the Welsh spelling of Rhiwbeina.

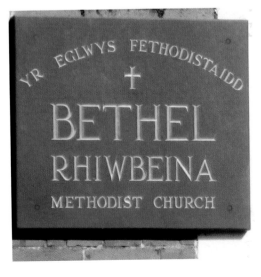
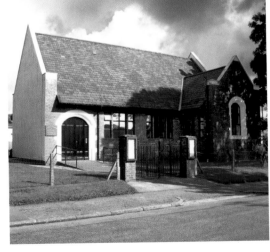

The Presbyterian Church of Wales (Calvinistic Methodist)

Calvinistic Methodism – called by some 'the true Welsh Methodism' – came into being in 1735, separately from Wesleyan Methodism, when Howel Harris of Talgarth and Daniel Rowland of Llangeitho had, independently of each other, conversion experiences that encouraged them to preach and gather followers. The first purpose-built chapel was at Groeswen, near Caerphilly, in 1742.

Other great names from the movement were Griffith Jones, who created the Circulating Schools to teach people to read the Bible, and William Williams Pantycelyn, the great hymn writer. Beliefs were personal conversion, assurance of sins forgiven and regeneration to a new way of life. All this was the action of God, manifested most clearly in Revival. Members remained within the established church until 1811, when they ordained their first ministers – men who could then no longer attend English universities, and, studying in Scotland, became influenced by the Presbyterian style of church governance. In the 1851 religious census, the Calvinistic Methodists were Wales' largest denomination. The church was renamed the Presbyterian Church of Wales in 1933.

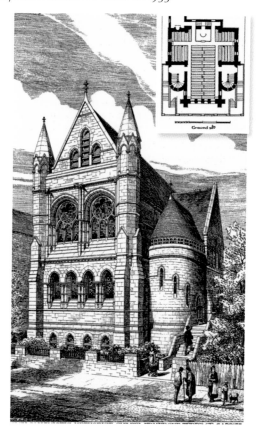

Despite the early chapel at Groeswen, Cardiff had to wait eighty-five more years for its first WCM chapel, which was Capel Mynydd Seion, opened in 1827 between Working Street and Trinity Street on the site of the old library. Seating 600 and in use for the next fifty years, it was sold (because of a road-widening scheme) to Cardiff Corporation for £6,500, and the church moved to a *cul-de-sac* called Pembroke Terrace, beside the dock feeder. This is today's Churchill Way.

This strikingly original French-Gothic-style chapel – no doubt influenced by Burges – was built by Penarth architect Henry Harris, aged twenty-seven, in 1878. With its gables, pinnacles, tracery and bow-fronted stair turrets, it drew a snigger from the architectural critics – 'The Welsh Calvinists will hardly know themselves soon!'

With the growth of suburban churches in Canton and Cathays, numbers declined and Pembroke Terrace closed at the end of 1975, the congregation joining Crwys Road church. The building was eventually sold to Wigley, Fox & Co., architects, for £110,000. The exterior of the listed building is preserved, and has undergone a recent period of renovation. Its fine polychromatic interior now houses a stylish restaurant, but it remains as a fine example of High Victorian chapel building.

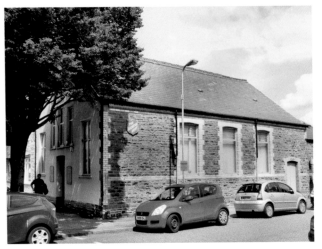
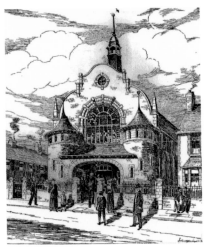

Capel Heol y Crwys

This little building, now used by the Salvation Army, opened in 1884 as Capel Horeb in May Street Cathays, with thirty-two members from Pembroke Terrace. The town's boundaries had been widened in 1875, taking in more of the Welsh-speaking population. It closed in 1900, three days before its members moved into Capel Heol y Crwys, the design of which appears opposite. Architect J. H. Phillips created a 'disconcerting hybrid' of 'romantic medievalism with Dutch Baroque'. John Hilling calls it 'a toy castle in front of a railway terminal'. It seated 600 and became a flourishing and popular Welsh Church, with a membership of 500 by the early 1980s. Its fine interior woodwork and massive organ are shown below. Serious deterioration in the building meant that in 1988 the church moved to Richmond Road, into the building previously built and owned by the Christian Scientists (*see page 69*). The exterior of the chapel remains unchanged, though in 1990 it became a mosque and is now known as the Shah Jalal Islamic Centre.

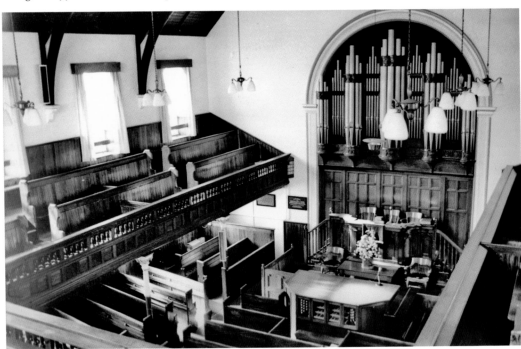

Eglwys y Crwys

Richmond Road English Congregational could have been mistaken for an Anglican church. It was a handsome Gothic edifice built in 1898, seating 800 and costing £6,000. Sadly it was completely destroyed by a bomb in March 1941. In 1963 the site was acquired by the Christian Scientists, who erected a white-brick, rectangular building with flat roof, where they held services until the 1980s. They then moved to premises in North Road, and in 1988 the Crwys Road congregation moved in. They modified the building by adding a pitched roof extending over the frontage to form a large, glazed porch. On the first floor, the rear of the building was converted into a theatre.

Now known as Eglwys y Crwys Presbyterian Church of Wales, it is a thriving place with well-attended Sunday services, morning and evening, and fortnightly Biblical Studies. Its subtitle, 'The Church of the Three Crosses', refers to its composition – the three congregations of Pembroke Terrace, May Street and Crwys Road coming together in this twenty-first-century building, as vigorous as ever.

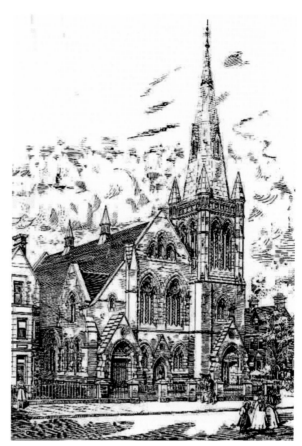

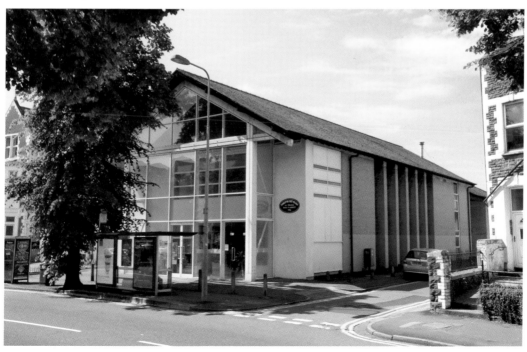

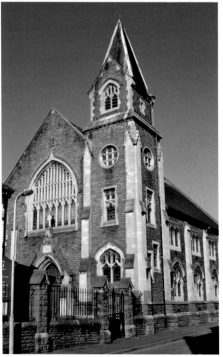

Salem Presbyterian Church of Wales
Salem was the third church in Canton, and now the only one with services in Welsh. Above is the original chapel on Albert Street, where the 'Plygain' (dawn service) was held at 5 a.m. on Christmas morning 1856. Membership increased following the 1859 Revival and, although a group seeking English services left in 1903, members determined to build a bigger chapel. New Salem opened on the corner of Market Road in 1911, known as 'the Cathedral of the Connexion' and a masterpiece of architect Edgar Fawckner. Cardiff shipowner Henry Radcliffe paid for quality fittings and also three shops, whose rents still swell the church's coffers today. Salem was the chapel of the Novello family; Ivor's baptism and his parents' marriage took place there, with mother Clara and grandfather Jacob Davies responsible for the music. Salem flourishes today under young minister Revd Evan Morgan. It is a rare church in Cardiff, that claims to have a Sunday school of over 200!

CHAPTER 9

The Forward Movement (Welsh Calvinistic Methodist)

Clifton Street Presbyterian church opened as a Welsh language lecture hall, Libanus, in 1868, but when the fine new chapel was built in 1880, services were then held in English. When Minister John Pugh arrived in 1889, he found a well-appointed chapel with cushioned seats and affluent members, and in 1891 he left 'to evangelise the lapsed masses of the town'. Nearby Splott was deemed to be the 'most needy spot' and, along with evangelist Seth Joshua of Neath, he set up a tent on waste ground in what is now Ordell Street – the Forward Movement was born.

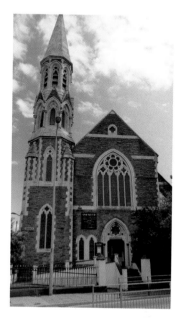

Within months he opened the wooden 'Noah's Ark' and by 1892 had built East Moors Hall, with financial help from Edward Davies of Llandinam. Pugh reckoned Cardiff had 128,000 people, with church seating for only 49,000, and he planned halls across the poorer areas of the city. By 1901 there were eight in Cardiff and forty across South Wales. They were urban and English-speaking, concerned with the welfare of the poor and Temperance. The demon drink was seen as the downfall of many working families. East Moors Hall in Carlisle Street is now a Community Centre. The David Davies Memorial Hall in Cowbridge Road, a huge pseudo-Jacobean building seating 1,250, was demolished in 1997. Others such as Crwys and Heath Halls have survived to become thriving independent churches today (*see pages 72 and 73*). Pugh, whose grave can be seen in Cathays cemetery, thought the danger of Presbyterianism was 'to be crippled by respectability and to die of starch'.

The church in Clifton Street, the springboard for a movement that for a while took Cardiff by storm, closed in 1967 when its lease expired and is now a craft centre called Inkspot.

Another Forward Movement hall that has survived is the King's Way Hall in Cathays, which began in 1887 as the Harriet Street Mission, from Windsor Place English Presbyterian (*see page 74*). In 1930 the Presbyterian Church of Wales bought it and renamed it the Cairns Street Mission. In 1935 Cairns Street became Rhymney Street, after protest from local residents whose street was so notorious for drink that it was nicknamed 'Flagon Alley'. From 1953–83, the Forward Movement's renamed King's Way Hall was run by three Sisters who cared for the poor and needy. It reopened in 1998 as the Harriet Street Welsh Evangelical church.

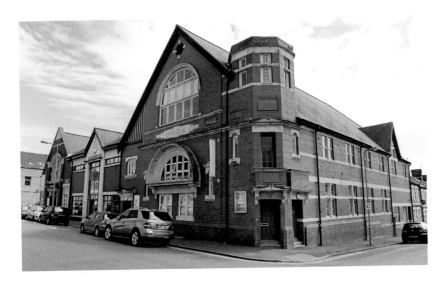

Highfields Church

The Forward Movement's Crwys Hall in Cathays opened in 1900 – two halls linked by two houses for church workers, in a simple Arts & Crafts style. On the corner was an external pulpit, still visible in the photograph above, though no longer used. It symbolised the desire of the Movement to take the message out to the people. Soon there were 1,000 children in its Sunday school. John Pugh's funeral took place here in 1907, and hundreds followed the coffin to Cathays cemetery. By the 1990s the building, then Cathays Presbyterian church, was closed, derelict and pigeon-infested. In 1997 it was bought by Highfields Free Church, a breakaway group from Heath Evangelical church. By 2003, an expensive renovation had created an upstairs chapel with baptistery, a suite of rooms below and a foyer block. Today Highfields is one of the most thriving churches in the city, with hundreds at each service and active missionary work at home and abroad. The picture below shows the chapel today. Although the massive organ has gone, the cast-iron roof, the columns with carved capitals and some of the pews from the old gallery remain. John Pugh would perhaps look down and smile.

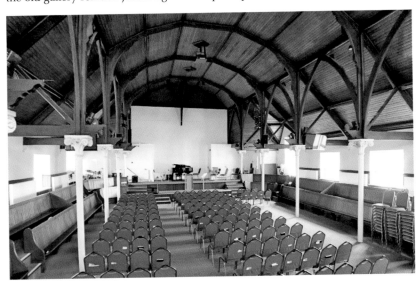

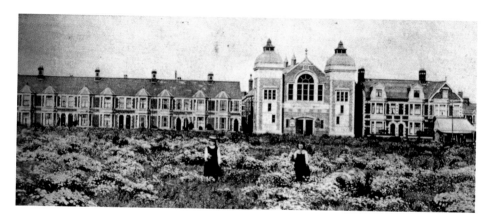

Heath Evangelical Church

In 1900 the Heath Forward Movement Hall was built on this outer edge of Cardiff; by 1904 it was 'alive with revival fire'. The year 1906 saw a new church built, and Seth Joshua's mission of 1907 described the church as 'waiting the coming tide'. People started to queue for services, and missionary work was strong both at home and abroad. From the 1960s, the church fought against ecumenism, favoured by the Presbyterians, fearing the taint of 'liberal theology'. In 1971, it seceded from the denomination and became Heath Evangelical church. The building was bought after a struggle involving sit-ins! Missionary and student work expanded, and with 900 members in 1985 it was probably the best-attended church in Wales. Later, a split caused loss of members and elders, who became Highfields church (*see page 72*). Thriving again, the church has Sunday schools, youth groups and Bible classes, with a Christian bookshop and coffee shop next door.

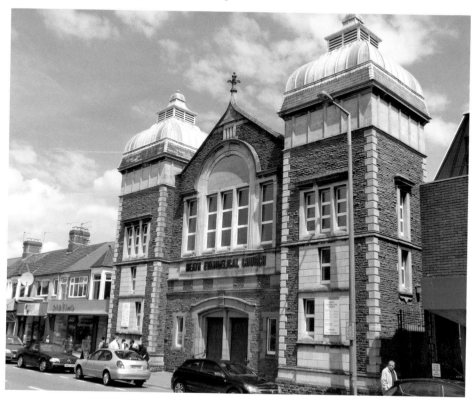

CHAPTER 10

The English Presbyterians (Now United Reformed Church)

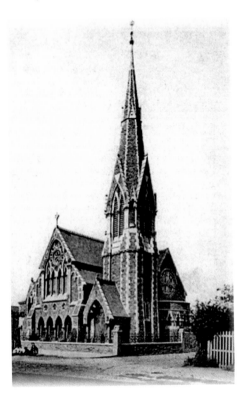

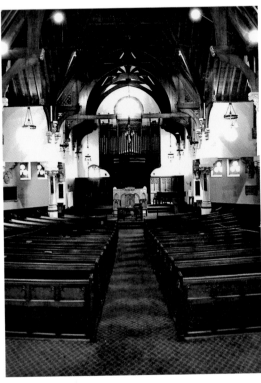

The English Presbyterians had only two churches in Cardiff, in the town centre and Roath. Both congregations were founded by the Scots, but known as English because that was the language of worship. In 1972, they amalgamated with the Congregational Church to form the United Reformed Church. They emphasise the Bible and preaching, but also theological and cultural diversity, seeing a variety of insights as providing more knowledge of the wonder of God.

A group of exiled Scottish Presbyterians, attracted to Cardiff in the wake of the 2nd Marquess of Bute, began attending Charles Street Congregational but in 1864 moved to rooms in the Cardiff Arms. They opened their chapel in 1866 in Windsor Place, which was then a stylish street built on Bute land. The architect was Frederick Pilkington of Edinburgh, who built in lavish Gothic style, with porches, gables, tracery, a tower and an octagonal spire. It had a large galleried interior, 'a theatre of nonconformist drama', but this was gutted by fire in 1910 and rebuilt by Bruce Vaughan, who created a spectacular hammer-beam roof. In the 1970s, following the creation of the URC, it amalgamated with Charles Street Congregational to form the City United Reformed Church. It was thoroughly reordered in 1980 at a cost of £250,000 (compulsory purchase money from the sale of Charles Street). The church today is an inclusive church, which gives active support to gay and lesbian groups and asylum seekers, and houses the Cardiff Adult Christian Education Centre.

St Andrews United Reform Church

Roath Park English Presbyterian was perhaps the grandest chapel of all, seen in this old postcard in its newly built splendour around 1910. An offshoot of Windsor Place (*see page 74*), a hall of 1897 was built in Wellfield Road, then a country lane surrounded by fields, but which would become a main route to the newly-opened Roath Park. By 1900, a new church by Habershon & Fawckner was built in this up-and-coming area; it was a real 'showpiece'. Seating 1,000 people and costing £12,000, it was topped with a 150-foot spire in Bath stone with bands of pink Radyr – a magnificent structure enhancing the streetscape at the approach to the park. Its doorway is modelled on Tintern Abbey and its west window on one in Melrose Abbey. The congregation, as at Windsor Place, was largely Scottish. Support came from the Marquess of Bute and 500 of the seats were let. In the Second World War the hall canteen served more than 100 a day, to help with which the church plate was pawned!

Following the Congregational/Presbyterian Union in 1972, it became known as St Andrew's United Reformed Church, with a nod to its Scots origins. The Cardiff Caledonian Society meet there, St Andrew's Day and Burns Night are celebrated, and for some while their Scout group wore kilts! Today the service is still traditional, the congregation numbers around seventy and there is a small Sunday school. The hall is used on weekdays by various groups and in 2012 rewiring and redecoration have brought the church up to date. The people standing in the roadway in the old picture above would, today, be taking their lives in their hands at this now busy junction of Penylan, Ninian and Marlborough Roads.

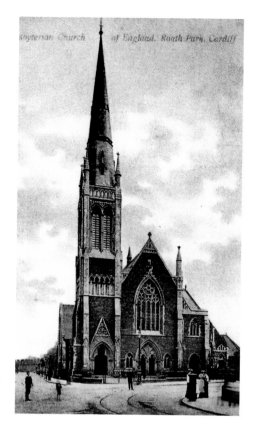

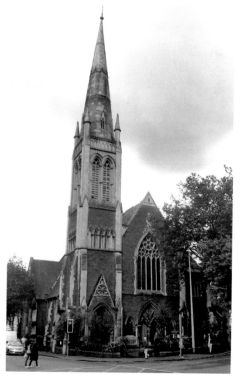

CHAPTER 11
The Roman Catholic Church

At the Reformation, the Catholic Church in Wales became part of Henry VIII's Church of England; Welsh monasteries were suppressed and, except briefly under Mary, Catholics were deprived and persecuted for 200 years. Priests were hanged, drawn and quartered for treason, and those refusing to attend the established Church were fined or imprisoned. Welsh Catholicism barely survived, except in Monmouthshire, where Catholic landowners maintained (and hid) their chaplains.

Things gradually eased and when the hierarchy of bishops was restored in 1850, Cardiff became part of the Diocese of Newport and Menevia. In 1916, it became a Metropolitan See with its own Archbishop. In the early 1800s the few Catholics in Cardiff were served by a visiting priest from Merthyr or Newport. Later, many Irish came to work in the docks, despite the fact that Lord Bute refused them land for a 'mass-house'. Mass in a cottage in Bute Street preceded a chapel of 1842 on the corner of David Street and Bute Terrace, now the site of the International Arena.

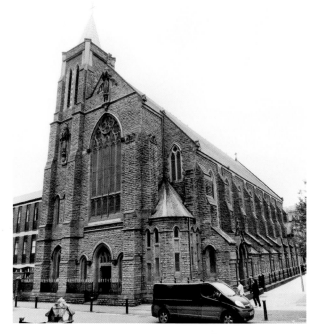

Built in neo-Romanesque style, the church was dedicated to St David. In 1887 a new church was completed in Charles Street, by architects Pugin & Pugin. Large and lofty, with a tall five-light window and a corner tower with stumpy spire, John Newman calls it 'a dark and solemn presence in the commercial hubbub'. It became the Cathedral of the Archdiocese of Cardiff in 1920, but in 1941 it was badly damaged by incendiary bombs, and the congregation had to worship in the old church, then the church hall. Restored in the 1950s under Price, Bates & Son, the cathedral, enhanced by Stations, organ and statues, reopened in 1959. The seventh Archbishop, George Stack, was installed in June 2011.

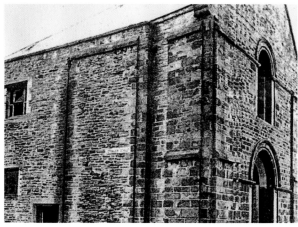

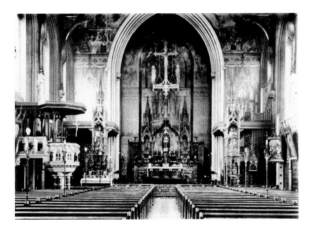
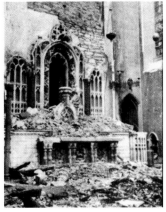

Inside St David's Catholic Cathedral

The photograph above shows a typical Catholic interior pre-Vatican II, and in this case before the Second World War bomb. A sumptuous high altar, gabled and pinnacled, with huge hanging rood, statues in tall canopied niches, banners and wall paintings, and a magnificent pulpit are all visible. All this was destroyed in the devastation of the bomb. The restoration by Bates added hammer-beam roof trusses, a reredos with diaper patterning and a honeycombed east window. The nave, which has no aisle, is flanked by side chapels and confessionals, and above the west stone gallery is an unusual window of the Immaculate Conception witnessed by Popes. Today, post-Vatican II, the interior is much simpler, the proliferation of decoration very much toned down and the clean-cut lines of the building more apparent. In 2012, the building formerly known as Charles Street Congregational and later Ebenezer Welsh Independent, was bought by the Archdiocese to be used for musical and social events. It is now known as 'The Cornerstone at St David's'.

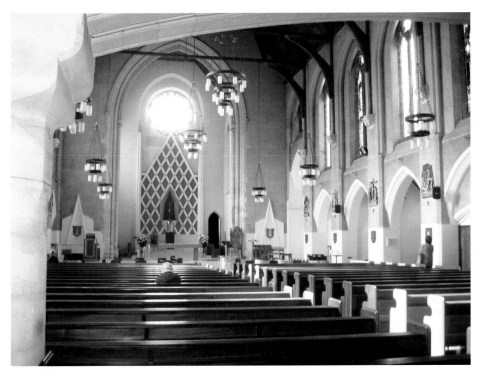

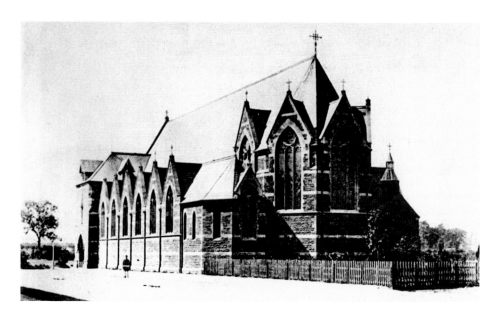

St Peter's Catholic Church, Roath

By the 1860s, Catholics made up a third of Cardiff's population, and were served by just one church, St David's. Priests from the Institute of Charity served the town, and raised funds to build a new church in the eastern suburbs, thinking that Roath and Penylan were where the rich were likely to settle! St Peter's, Roath, opened in 1861, at that time truly 'in the fields'. Designed by Charles Hansom, brother of the Hansom cab creator, a large church in Geometrical style was built with gabled roofs over wide aisles. The old photograph shows it lacking its later tower. Dreadful housing conditions, drunkenness and shortage of money made the priests' lives difficult, and poor attendance was a result of the church being so far from Irish Newtown. Also, plans for East Grove to reach Richmond Road were abandoned as a result of opposition to a 'Papist' church fronting a main road. Street collections and the Marquess' conversion in 1868 improved things. A school was opened opposite in 1872 and a presbytery (*below*) in 1873. In 1883 the tower was built at the expense of Lord Bute, and the peal of eight bells, paid for by the parish, was added a year later.

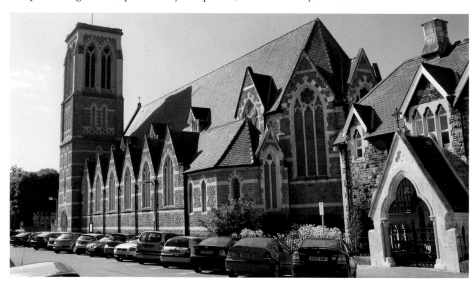

Inside St Peter's

St Peter's seats over 1,000 people, with a lofty spacious nave, an arch-braced timber roof and apsidal east end. The fine stained glass (1882) is by Meyer of Munich. The ornate rood screen (*seen right*) was given by Lord Bute in 1898. Stained-glass windows in the porch (1929) commemorate Catholic martyrs John Lloyd and Philip Evans. In 1948, with debt cleared, the church was finally consecrated. Following Vatican II, the interior was drastically reordered and many Victorian fittings, including the rood screen, were removed. Today, much has been reversed with the addition of the Victorian reredos, stencilled ceilings and walls, and Minton floor tiles. In 2006 a magnificent organ by Spath of Switzerland was given in memory of Sir Julian Hodge, Cardiff businessman and philanthropist. Modern touches include flat-screen monitors and glass doors at the west end. Today, the church, no longer dependent on the pennies of the poor, is a flourishing place inside and out.

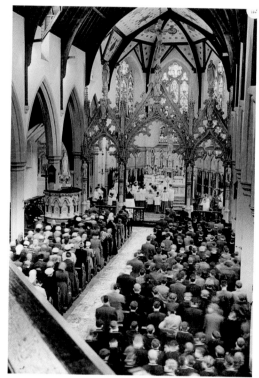

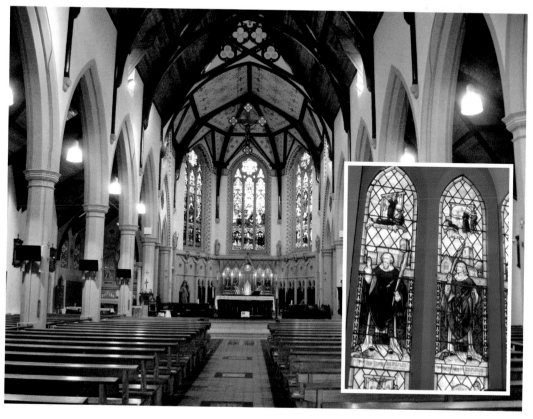

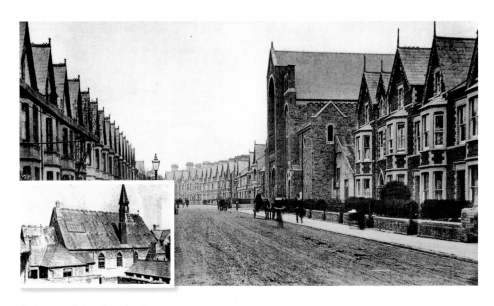

St Mary of the Angels, Canton

St Mary of the Angels, Canton (Llanfair yr Angylion), is the third oldest of Cardiff's Catholic parishes. A school and mass centre in Wyndham Crescent were built in 1896, serving the influx of Irish dockworkers. Under the care of the Benedictines from 1897, first an iron church then a permanent one of 1907 were built in Kings Road. Architect F. A. Walters, designer of Buckfast Abbey, chose a Romanesque style, with spacious nave and aisles, and arcade arches with waterleaf capitals enclosing the clerestory windows. In 1914, the Marquess of Bute attended the opening of the extended church, now with confessionals, sacristies and stained glass. Choir stalls and screens followed, and in 1919 the St Anne's chapel was created in the south aisle. The north-west tower opened in 1937. In 1951 rebuilding and redecoration took place after bomb damage, and in 1953 the church was finally consecrated by Archbishop McGrath (*below*). Reordering took place in 1974 under architect George Pace and again in 2000 to comply with liturgical changes. More refurbishment celebrated the church's centenary in 2007. Above, we see the old school and mass centre with a virtually traffic-free Kings Road and the church building awaiting its tower.

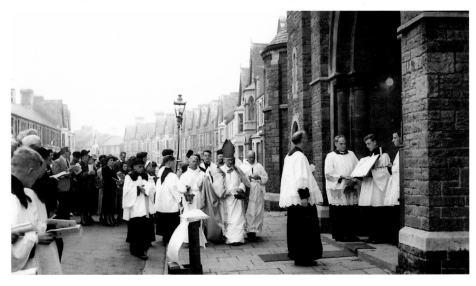

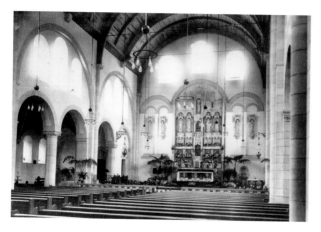
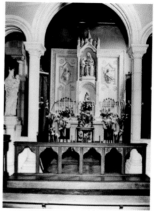

Inside St Mary's

St Mary's interior, with its architecture of French character, is fundamentally unchanged from its completion in the early years of the century. In the early picture above, of around 1920, there is no hanging rood cross, and the rather ugly light fittings have since disappeared! The glory of the east end is the huge reredos, with its carvings of the *Agnus Dei*, Risen Christ and Virgin Mary, rising up to three small stained-glass windows of the Holy family. Statues on the east wall include St Benedict, recalling the Benedictine monks who cared for the parish until 1991. Stained-glass saints surround the church, many of them British, including two Welsh Catholic priests martyred in the seventeenth century. Side chapels of St Anne (*seen above*) and the Sacred Heart are also lavishly decorated. The former baptistery is now the Lourdes Grotto, recalling the vision of St Bernadette in 1858. The recent reordering and restoration has further enhanced this treasure house of rich materials and fine craftsmanship.

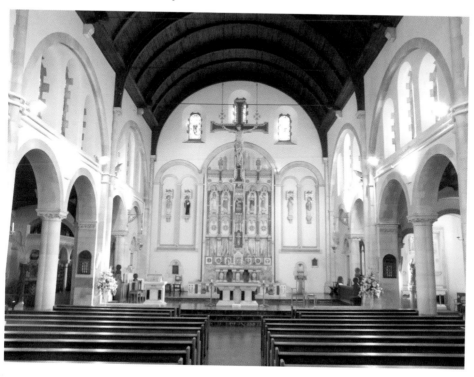

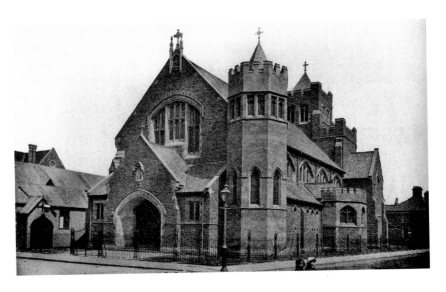

St Alban's Catholic Church, Splott

East Moors, the area around the old Splott and Pengam farms, was a marshy waste, with tidefields broken up by ditches and gates. However, by the 1880s, houses, shops and pubs were being built, and St Alban's Mission opened in 1891. Lord Bute contributed to the work and attended the opening service. Chapel, altar and reredos came from St Peter's and a rood from old St David's. Downstairs, the infant school had one teacher with an assistant aged fourteen! The Dowlais Steelworks attracted Catholics to the Moors; the Marquess bought an iron building, which was replaced by the present Perpendicular Church in 1911. Architect F. R. Bates created both a central tower and an unusual octagonal one. The plain and spacious interior, flooded with light, has a five-bay arcade, a wide ambulatory, a pulpit given by the blast furnace men, and a Lady Chapel with a fine Pugin altar from St Marie's Rugby. Statues of St Alban and Our Lady of Lourdes were exchanged for the old iron building, the forerunner of St Joseph's church at the Heath. The old school moved to Tremorfa, enabling a new parish hall, now a hive of activity, to be built close to the church.

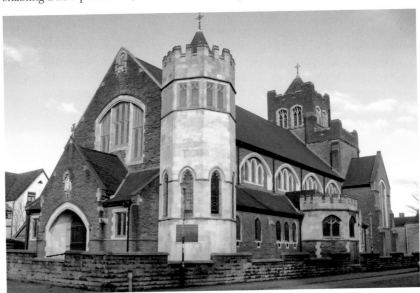

St Paul's, Newtown & Cyncoed

When the 2nd Marquess of Bute opened his first dock in Cardiff in 1839, he employed many workers from Ireland, who often travelled as 'ballast' in coal ships, fleeing the impending potato famine. They settled in a little community immediately north of the Bute docks, in six streets of tiny houses, with pubs, corner shops and, from the 1870s, their own Catholic Church. St Paul's in Tyndall Street, Newtown, began as a school chapel. It was 'permanently full', and soon a larger building was needed. The foundation stone was laid in 1891 by the 3rd Marquess and his young son, who deposited generous cheques to help pay for this much grander building. It seated 800 in nave and gallery, with fine fittings. The famous boxer, 'peerless Jim Driscoll', worshipped there, and thousands lined the streets when his funeral procession wound its way to Cathays cemetery in 1925. The church closed in 1967 and was demolished in 1970, along with most of Newtown, whose inhabitants were moved to outlying estates. Memories are kept alive by the Newtown Association, who in 2005 created a memorial garden in Tyndall Street to commemorate the community and its church – 'the beating heart of little Ireland'. In 1975, a modern church was built in Cyncoed Road and dedicated to St Paul, so continuing one of the oldest Catholic dedications in the city.

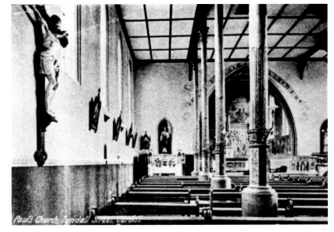

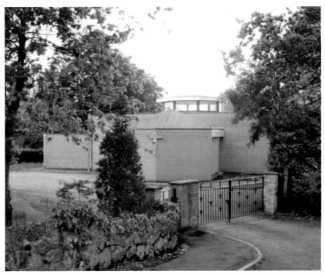

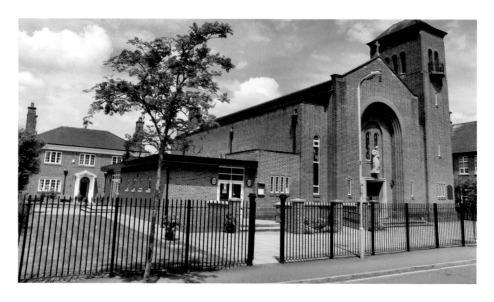

St Joseph's, Heath & St Francis, Ely

St Joseph's Mission at the Heath in Gabalfa started in 1911, reusing the iron building formerly at St Alban's, Splott. The fine basilican style church (*above*) was built in 1935 in New Zealand Road, largely financed by £10,000 given by a Mrs Edith Callaghan of Newport. Built of brick, it has an impressive tower, baptistery, gallery and aisled nave, with oak woodwork and terrazzo flooring. The fine presbytery sits behind, and the adjacent school, still flourishing, was opened in 1927.

Though St Francis, Ely, began in a church hall in 1927, today it is housed in a striking modern building of 1960 by T. Price of F. R. Bates & Son, listed because of its idiosyncratic appearance, which reflects the exuberance of the 1960s. With a jagged roof over lozenge-shaped windows and openwork campanile, its interior has flying buttresses carrying the gallery, faced with a series of Stations of the Cross by Adam Kossowski in ceramic and a background of sgraffito. Ely has many churches, but this is certainly the most unusual!

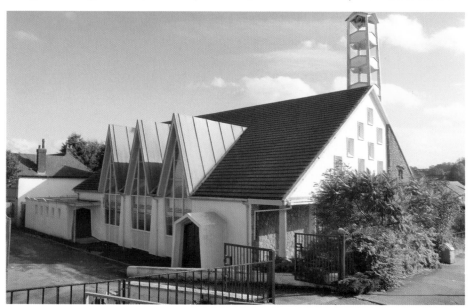

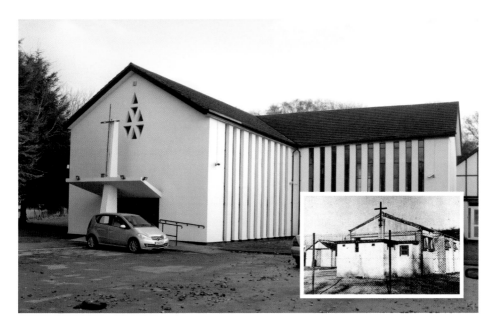

St Brigid's & Christ the King, Llanishen

St Brigid's in Crystal Glen opened in the temporary building when the Llanishen area of Cardiff was growing fast. The present modern church, by architect F. R. Bates, replaced it in 1964. An offshoot of St Brigid's was Our Lady Queen of the Universe, which opened in 1955 on the Llanishen estate. When the present church was built in 1978, the dedication was changed to 'Christ the King', as the old dedication had prompted the nickname 'Miss World'! The old building is now the church hall, which, along with the church, was refurbished in 2011.

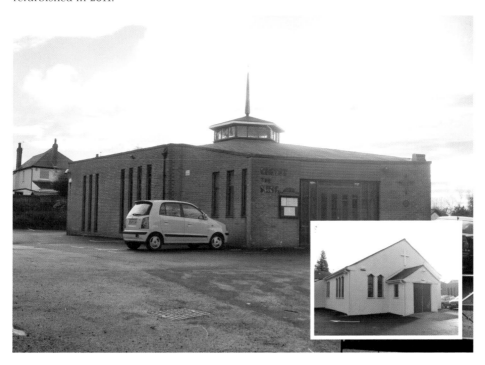

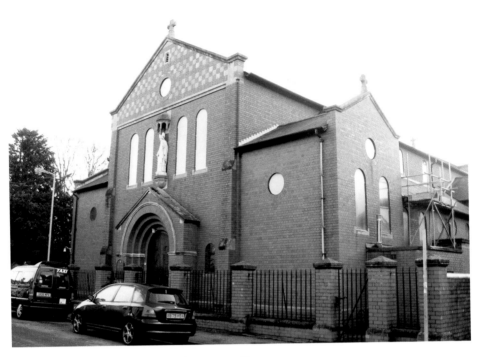

St Patrick's, Grangetown & The Blessed Sacrament, Rumney

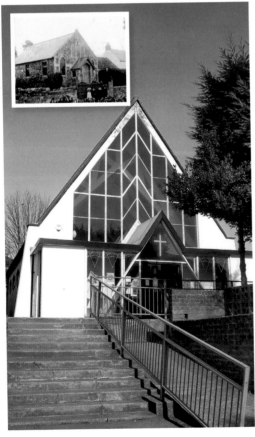

St Patrick's, Grangetown, an early Catholic mission from 1866, was served by the Rosminian order, mass being said in houses and an Irish pub. The school and church opened in 1884 with no chancel or baptistery, and the infants were taught under the gallery! The red-brick church, above, in Romanesque basilican style, was erected in Grange Gardens in 1930 by architect James Goldie and builder Ephraim Turner, who built Cardiff's City Hall. The church of the Blessed Sacrament, Rumney, is a striking modern building – a prime example of 1960s architecture erected on the site of the old Rumney Baptist chapel. Its photograph (*inset*) is dated 1905. The new Catholic Church, designed by F. R. Bates, has a dominating triangular roof and fully glazed entrance front; its style is thought to have been influenced by the work of Basil Spence of who designed Coventry Cathedral. The church is set well back, and the old chapel site now bears a statue of the Blessed Virgin Mary.

Other Denominations, New Uses and a New Form of 'Church'

Other denominations – the Greek Orthodox, the Bible Christians, the Primitive Methodists, the Gospel Halls, the Elim Pentecostal, the Unitarians, the United Methodists, the Quakers and more – have all figured in Cardiff's religious history. Some still flourish today, while others have faded and their buildings turned to other uses. New churches with strange-sounding names have appeared – sometimes in unlikely places – but they are all part of the story.

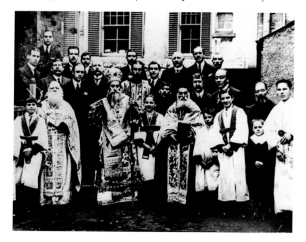

The church of St Nicholas, Bute Street, is Cardiff's only Orthodox Church. By the turn of the twentieth century many Greeks were living in the cosmopolitan Butetown, and the wealthier among them raised the money for a church of their own in 1906. Built with red bricks and a copper-covered dome, the church's exterior is quite inconspicuous, closely hemmed in by other buildings. But the interior is a revelation. A shallow foyer at the west end leads into a breathtaking space, the plastered walls and ceiling almost totally covered with lavish painting and decoration. Saints abound: on the Iconostasis, the screen closing off the sanctuary, around the walls, and high above – the underside of the dome has the central figure of Christ Pantocrator, ruler of the world. At the west end, with St Nicholas, the church's patron, are scenes of Pentecost and the Transfiguration. Many of the icons are painted on canvas, some of them in Greece, and then attached to the walls and ceiling. This view from the west gallery shows the beautifully finished interior, fully restored in 2002. The picture above shows members of the church celebrating the consecration of the building in May 1919. The prelate in the wonderful hat is Cyril III, Archbishop of Cyprus.

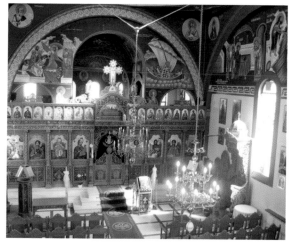

George Jeffreys & Beginnings at The City Temple

Cardiff City Temple

The official name of the movement is the Elim Foursquare Gospel Alliance, and its flagship church in Cardiff is the City Temple, built in 1934 opposite Sophia Gardens. The founder was a Welshman, George Jeffreys, who was converted in Maesteg in the 1904 Revival. Beginning as a Welsh Independent, he left for Ireland in 1915 and founded the Elim Evangelical Band. He registered the denomination in 1917, to avoid paying tax on a legacy they had received. In 1929 he was back in Cardiff where he rented the Cory Hall in Station Terrace for two weeks. His meetings were packed, and in fact extended to fifty-one nights. Over 3,000 people were converted and there were many dramatic healings. When Jeffreys left for Swansea, his followers continued to meet and founded the City Temple in 1934. (Jeffreys is seen above, laying the foundation stone.)

The name 'Elim' comes from an oasis in the desert found in the Book of Exodus, a place of five wells and seventy palm trees. 'Foursquare' refers to core beliefs – Jesus as saviour, healer, baptist and coming king. A famous healing pastor was Percy Brewster (1939–74) who also introduced lively music and 'neon-lit' religion. He drew crowds of more than 1,000, with a Sunday school of 600. The church today has a congregation of over 500, of all ages and classes, in which forty languages are spoken. Holy Communion is celebrated weekly and prayer is extempore, but healing is more discreet these days and it is recognised that only some can heal. The social gospel is very strong: weekend accommodation and food distribution is offered to the homeless, there is an advice centre in Llanishen and a charity shop 'Re:new' in Canton. There are 550 churches in the UK, the largest of which is the Kensington Temple with 6,000 members. Other Elim centres in Cardiff are at Danescourt and St Mellons.

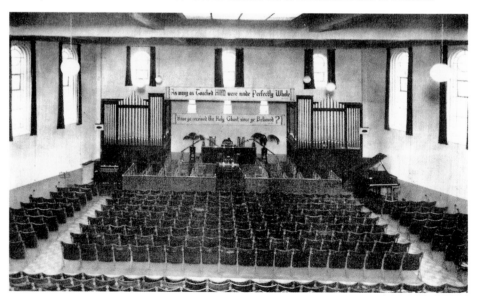

The Religious Society of Friends & The Unitarian Church

Often known as the Quakers, the Friends began in mid-seventeenth-century England with a man called George Fox disrupting church services and bidding magistrates 'tremble at the word of the Lord' – hence the nickname 'Quakers'. He believed in the priesthood of all believers, without the need for priests or ministers. Many Quakers emigrated to America, fleeing persecution and imprisonment. Quaker meetings have no formal structure; there are no sacraments and no ministers. They are pacifist, anti-slavery and capital punishment, and teetotal. Many went into the chocolate business, an alternative to alcohol. Ethical Quaker banks were started by Lloyds and Barclay's. Cardiff's early Quakers were John ap John, a convert of Fox, and Dorcas Erbury, daughter of Cardiff's first protestant minister (*see page 44*). Their meeting house opened in Charles Street in 1838; the present one, occupied since 1888, they now share with the Unitarians.

The Unitarians, named for their rejection of the doctrine of the Trinity, met in Cardiff in 1879 at the Great Western Coffee Tavern. The chapel in West Grove opened in 1887, in a semi-Queen-Anne-style, Grade II listed building. Liberty, reason, an informed conscience and openness to scientific enquiry were its watchwords. It attracted many leading thinkers, including the founding fathers of the USA. The church in West Grove thrived initially but, with later decline, in 2005 the congregation decided to sell up and continue at the Friends' Meeting House on Sunday afternoons. The building in West Grove now houses the United Church of the Kingdom of God (UCKG), in the UK since 1995. Holding evangelical beliefs, they open the building every day as a help centre offering advice on personal issues such as marital problems and drug addiction, etc.

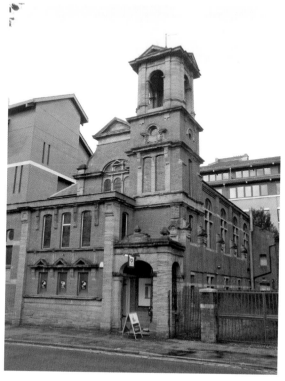

The Brethren

The Brethren, formerly known as the Plymouth Brethren from their place of foundation, are Christians 'who gather only in the name of our Lord Jesus Christ'. Their places of worship are called Gospel Halls; they have no ministers and all male elders. Women play a secondary role and until recently were not allowed to speak in a meeting if a man was present in some places. They baptise by immersion, and attendance is compulsory as a condition of membership. In Cardiff, their beginnings were in 1852, in a room in Newtown close to the docks, but by 1877 they had built their first Gospel Hall in Adamsdown. It was built on the site of the old Adamsdown Farm, was in Gothic style and seated 400. The exterior of the building is unchanged today, except that the entrance is now in Kames Place following the opening of the railway footbridge. The church was evangelistic, holding open-air meetings, and founded other halls, notably the Mackintosh in 1897. A packed hall in days gone by, numbers are now smaller. The hall has been re-roofed and refurbished and the stonework cleaned after years of pollution from the former steelworks.

Ebenezer church – formerly Gospel Hall – is in Corporation Road Grangetown. The cause was begun by Mr Gale, the superintendent of HMS *Thisbe*, the seamen's mission ship (*see page 39*), in two rooms above a stable in Eleanor Place, known as 'Seaman's Bethel'. Other venues followed, including 'Auntie Ann's' (former shop), until the hall was built for £1,250 in 1899. Like other Brethren, they sent out evangelistic teams to the Valleys, known as the Grangetown Tract & Bible Band, who operated up to the 1960s. The large basement, which has functioned as soup kitchen and air raid shelter in the past, holds meetings for groups of all ages. On Wednesday, an open coffee morning takes place, and on Thursdays an English class for local women and taught by women is held. Numbers peaked at 300 members in 1947. Today, although attendance is smaller, the church is a welcoming place, one of its main aims being to serve the community. The name has been updated to Ebenezer church, but its teaching and building remain much the same.

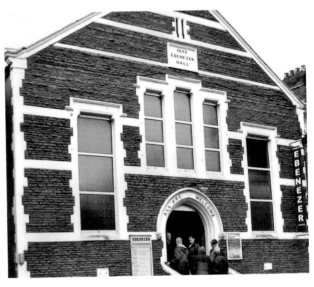

Canton Gospel Hall & St Paul's Seventh Day Adventist Church

The Canton Gospel Hall in Romilly Road was built in 1859 for Wesleyan Methodists, a long-walled chapel in what was then open countryside. When the Wesleyans moved to Conway Road (*pages 62 and 63*), the little chapel was used by the members of Severn Road Welsh Independent who wanted English services. In 1894, the Brethren moved in and are still there to this day. The chapel looks much as it did in the grainy old photograph (*right*), with its long, round-headed windows and neatly painted exterior. Local author Howard Spring wrote: 'the Brethren prayed for those Wesleyans who attend Conway Road in their top hats'! Top hats long gone, I doubt they still do.

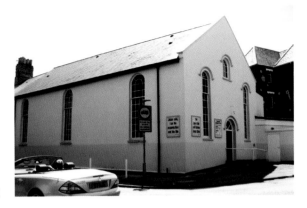

St Paul's Seventh Day Adventist church in Cowbridge Road began life as an English Congregationalist church in 1898, a handsome Perpendicular building. Since the 1950s, it has been used by the Seventh Day Adventist Church, which, distinctively, celebrates Sabbath on a Saturday as the Jews do and as Jesus would have done. They emphasise a healthy lifestyle, abstaining from foods such as pork and shellfish. They believe strongly in the Second Coming, hence the name Adventist. Holy Communion, with grape juice, is a very special event held once a quarter, along with foot washing. On Saturday mornings, an hour of Sabbath school is followed by 1½ hours of Divine Service. St Paul's is well-attended with a mixture of nationalities and a strong sense of fellowship.

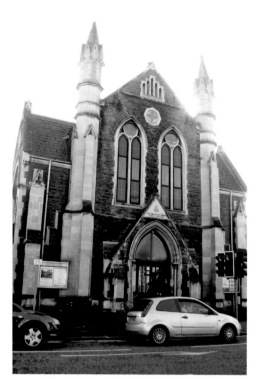

The Salvation Army

The Salvation Army, evangelising with 'soup, soap and salvation', and 'waging war' with bands and uniforms, brought their down-to-earth, 'love thy neighbour' Christianity to Cardiff, meeting in the Stuart Hall, before moving to Canton. In 1965 they bought this chapel in Cowbridge Road, built in 1899 for Bible Christians. The Cardiff Canton Corps adapted the interior: galleries were removed, the main hall carpeted, a platform and a Mercy Seat were added, and offices and meeting rooms were installed. An attractive and functional space, it has a lively congregation of over 100. The Grangetown Corps meets in Corporation Road, in the old Siloam chapel, bought in 1956 from the Baptists. The converted building, with a glass-fronted entrance, offices, a community room and a tea bar, holds a luncheon club, and computer training is run jointly with the YMCA. One gable-end is traditional; the other has a modern window donated by architects Huw Griffiths of Swansea.

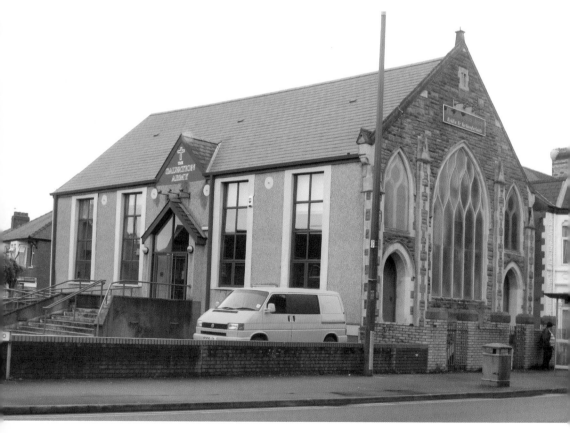

Splott Citadel & The Ely Corps

The old Mount Hermon building on Splott Bridge looks a sorry sight today, with windows broken and trees sprouting through the roof. It was built in 1892 for the Primitive Methodists – a self-explanatory name – but was used by them only until 1917. Then it became the Salvation Army Citadel and remained so until the 1980s. Commercial use followed, including as a furniture saleroom, but its state of dereliction makes the 'For Sale' board look over-optimistic.

The Salvation Army Ely Corps first met in peoples' homes, later in a tent, and then in 1939 a simple gable-ended hall was opened. By the 1990s it was dilapidated, and demolition was more sensible than repair. Built on council land in a deprived area of the city, and on the basis of the community work of the Salvation Army, the local authority agreed to assist with funding a new building. With help from the National Assembly, the European Regional Development Fund and others, a new centre was begun on the old site in 2003. Ingenious planning has created a V-shaped building, with a main hall used by the community during the week and for worship at weekends and evenings. Offices, rooms for toddler groups and the luncheon club, a kitchen, a tea bar, an accommodation extension and state-of-the-art electrical and computer facilities with PA and loop system make this a truly multi-purpose centre. Even the roof tiles are of vandal-proof steel. An expensive building costing £630,000, it is warm and welcoming, and is in constant use by worshippers and any in need of practical or spiritual help.

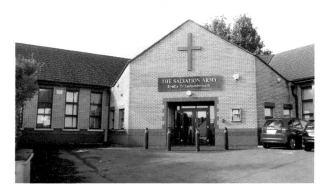

93

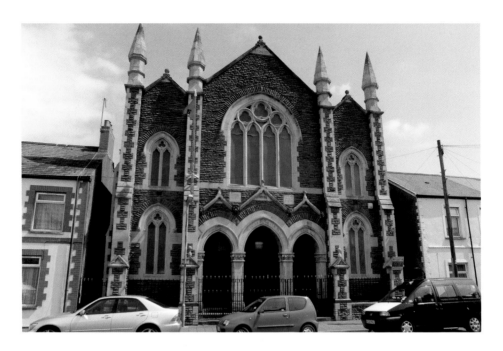

Ebenezer Baptist & Mount Tabor Primitive Methodist

Ebenezer Baptist church in Pearl Street was built in 1893, with shipowner Richard Cory a staunch supporter. For many years the church thrived, but other Baptist chapels sprang up and decline was followed by closure in 1976, the congregation moving to the new Belmont Baptist in Tweedsmuir Road. The fine chapel building became a Sikh Gurdwara in 1977. The customary Nishan Sahib, an orange flag, bears the Sikh Khanda symbol of circle and swords. Mount Tabor Primitive Methodist chapel opened in Moira Terrace in 1875. When the Primitive Methodists were absorbed into the Methodist Church, the chapel became redundant, and in 1953 it reopened as the Cardiff Reform Synagogue, renowned for its fine stained glass.

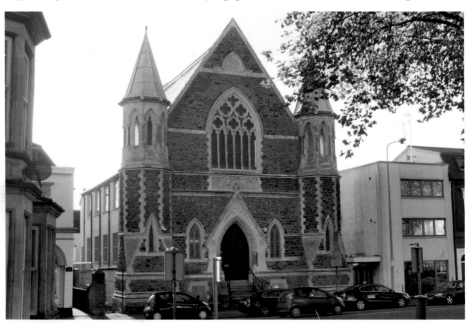

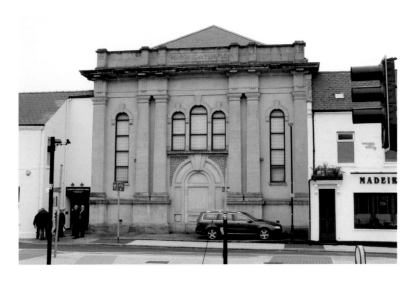

The Masonic Hall & El Shaddai

The Masonic Hall in Guildford Street was built in 1863 for United Methodists by architect John Hartland, who built Tabernacl and Bethany Baptist churches in 1865 in the Classical style. Minister William Watkiss left for popular acclaim at Wood Street Congregational (*see page 48*). The UMFC's congregation moved to Trinity, Newport Road, and the building was sold to the Freemasons in 1894. Freemasonry is one of the world's oldest secular fraternal societies, which holds three basic tenets: brotherly love, relief (charitable work) and truth. The hall is the home to more than fifty craft lodges and has a growing reputation as a venue for weddings, celebrations, conferences and meetings. On the Open Doors weekends, the public is given guided tours of this splendid building.

Churches have converted to other uses, religious or secular. But in the picture below we see the opposite. The old Splott cinema (1913) became a bingo hall in 1961, but in 2009 became the El Shaddai Christian Centre, one of several in British cities since 1998. The congregation now meets in the Park Inn, Llanedeyrn; will the old cinema find a new incarnation?

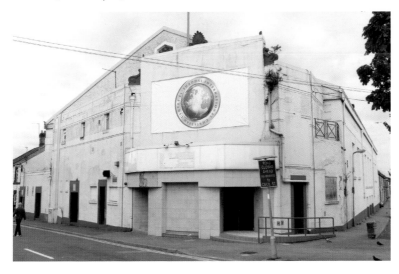

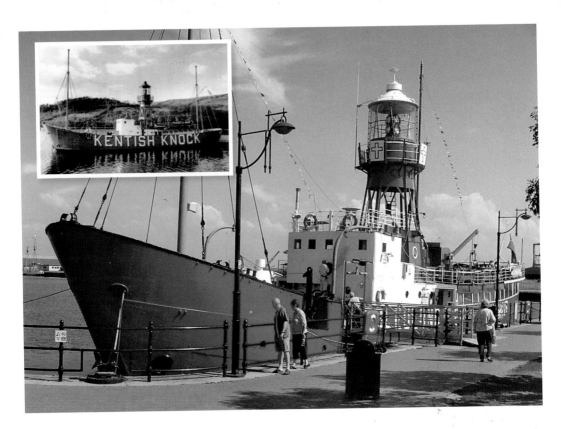

The Cardiff *Lightship*

The most unusual 'church' in Cardiff is no doubt the *Lightship 2000* (Welsh: *Goleulong*), moored alongside Harbour Drive in Cardiff Bay. For forty years a working vessel, she was launched in Dartmouth in 1953, commissioned by Trinity House, and was initially stationed off the Kent coast. Weighing 550 tons and with a crew of eleven, she was built to withstand the might of the sea. After serving in several locations, and by then with a helicopter landing platform, she was towed in 1984 to the Gower coast. Known as the *Helwick LV14*, her beam, visible 25 miles away, warned sailors of the Helwick Swatch, a treacherous sandbank off Rhossili. Her working life ended in 1989 but now, over twenty years later, she is still serving the community in a rather different way.

With help from the Cardiff Bay Development Corporation, *LV14* was purchased in 1993 and the restoration began to create a floating Christian Centre, an ecumenical project in which the churches of Cardiff work together. Its chapel, where Holy Communion is celebrated on Wednesdays at 1.15 p.m., is available during opening hours for prayer or meditation, and can also be a unique venue for a wedding, blessing, baptism or other special service. The Cardiff Bay Ecumenical Chaplaincy team is based on board, and offers pastoral and spiritual care to visitors or those who work in the bay. Chaplains can act as a bridge between organisations, issues, needs, people and networks, and between spirituality in the workplace and the rest of life. For the tourist, visitor or local, the *Lightship* is one of the Bay's major attractions, providing a refreshment area and venue for exhibitions and meetings. Engine room, wheel house, tower, mess rooms and cabins can all be seen, and the galley/lounge serves appetising food and drink at competitive prices. A non-profit making venture, it relies on volunteers for maintenance, help in the galley and as tour guides. With no denominational barriers, as well as fun and food, this is truly a 'church' of the twenty-first century.